IMAGES
of America

MARLBOROUGH

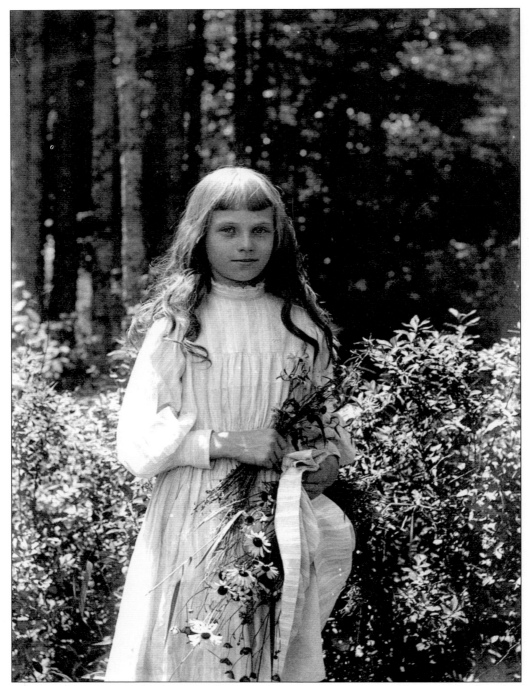

PICKING BLACK-EYED SUSANS. Pauline H. Morse was nine years old in 1891, when her photograph was taken here. When she became a teenager, she and her friends took bicycle rides to sites such as the old North Bridge in Concord. Her father, Walter, became Marlborough's eighth mayor and was instrumental in convincing philanthropist Andrew Carnegie to donate funds for a new library to be built on West Main Street.

IMAGES
of America

MARLBOROUGH

Susan Alatalo
with the Marlborough Historical Society

ARCADIA

Copyright © 2003 by Susan Alatalo and the Marlborough Historical Society.
ISBN 0-7385-1215-X

First printed in 2003.

Published by Arcadia Publishing,
an imprint of Tempus Publishing Inc.
2A Cumberland Street
Charleston, SC 29401

Printed in Great Britain.

Library of Congress Catalog Card Number: 2003105431

For all general information, contact Arcadia Publishing:
Telephone 843-853-2070
Fax 843-853-0044
E-mail sales@arcadiapublishing.com

For customer service and orders:
Toll-free 1-888-313-2665

Visit us on the Internet at www.arcadiapublishing.com.

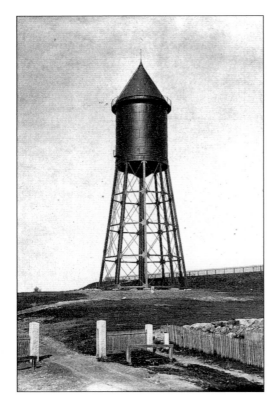

THE STANDPIPE. Visible for miles around, Marlborough's familiar water tower atop Sligo Hill was built by the Chicago Bridge and Iron Company at a cost of $95,225 in 1895. Built solely for emergency fire protection, the sight of this 33-foot high tower is a relief for many weary travelers returning home from a long trip down Route 495. The top is 611.25 feet above sea level. The tank holds 200,000 gallons. It sits at the head of Arnold Street.

CONTENTS

ACKNOWLEDGMENTS

Through the years, the quiet work of the archivist, collector, and historian accumulates. My gratitude peaks when these preserved layers of information are distilled to reveal rich discoveries in a never-ending hunt for knowledge.

Wherever no credit is listed at the end of a caption, the image belongs to the Marlborough Historical Society. Many thanks go to the society, especially its curator, Richard Wilcox; president, Jack Gracey; vice president, Frank Valianti; treasurer, Eugene Schneider; and former curators, Virginia Johnson and John Moran.

In addition to photograph contributors, I would also like to acknowledge the support of the Marlborough Public Library's director, Elizabeth Marcus Wolfe, the board of trustees, past and present, and the library staff, as well as Mayor William J. Mauro and Lynn Faust of the Marlborough Historical Commission, Anne Forbes, John Rice, Nancy Langelier, Paul H. Hayes, Arthur Jacques, Hector E. Moineau, Ruth Thomasian, Alfred E. Brigham Jr., Sue and Sid Brigham, Alex Stark, Joan Hartley Abshire, Dr. Kenneth and Elaine Greenleaf, Robert Scott, Cliff Gaucher, Mary Giorgi, Brian Pare, Marilyn Spencer, Mary Wenzel, Ed Bridges, James Toohey, John and Claire Noble, Joe Cusson, John and Marie Harrington, Fred Hollis, Beth Kelleher, Ellen Dolan Hayden, Ellen Muise, Hazel Miele, Ann Cross, Georgette O'Rourke, Alan Kattelle, Mary Ann Robbins, Ralph Sheridan, Elizabeth Schnair, Jimmy Delaney, Dick LaFreniere, Jane Biagi, and finally, foreign-born Duncan and Jack Ridler, who first instilled in me appreciation of local history.

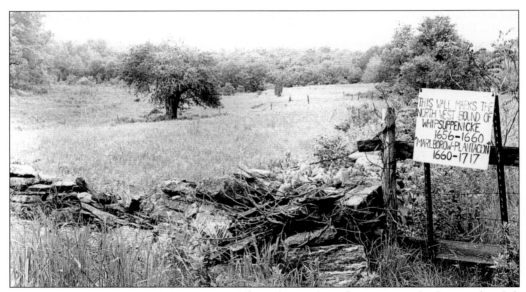

WHIPPSUFFREDGE INDIAN PLANTATION. When glaciers from the ice age melted away, they left behind stones that were used by Native Americans for ceremonies and, later, by European farmers for walls. Fertile, arable land attracted both groups of people, who thrived by utilizing sandy ridges and hills called eskers and drumlins, as well as various bodies of water, such as vernal pools. The settlement was also called Whipsuppnicke by Native Americans, who did not have a written language until Rev. John Eliot translated a Bible and established a number of "Praying Indian Towns" in Massachusetts.

INTRODUCTION

In 1656, several inhabitants of Sudbury petitioned the General Court for land to form a new town west of theirs, which was becoming smaller, it seemed, as the growing population continued its dispersion into the once open spaces. They were in search of more land for homes, barns, and churches; more fields for cows, orchards, and farming; and more space for families, townspeople, and parishioners. In 1660, their petition was granted, and the plot of land just west of Sudbury was established as Marlborow.

Marlborough, as it is now spelled, much like many of the good old towns of the mid-17th century, had its early beginnings in varied forms of farming and agriculture. Large-acre farms dotted the hilly landscape from north to south as far as the eye could see. But for the occasional wood-framed house or barn, or cluster of tall pines not yet felled to build another house or barn, the land was flat and thick with growing grains, grazing cows, and sustaining vegetation.

Remaining a mostly agricultural town for the better part of its first 200 years, Marlborough turned to manufacturing and transportation in the mid-19th century. The railroads and the shoe industry were with this small town as it grew into a bigger town and then a city. These industries, as consequential as they were, saw a booming Marlborough into and through the first half of the 20th century.

Today, most of the farms are gone; none of the engines that ran on any of the railroad lines in Marlborough blow their whistles anymore; and the last of the large shoe factories was not around for the arrival of the 21st century. There is, however, the present: a vibrant, high-tech, culturally-diverse crossroads between Boston's closest western suburbs and the rest of central and western Massachusetts. And today's Marlborough has just as much character and charm as did the 17th-century Colonial farming town.

However, in order to appreciate what Marlborough is today, we must study its past. Indeed, to know what came before us is to know what is here today and, perhaps, what is to come tomorrow. Education, respect, and preservation of our history will make us better stewards of what is here now. Though many of us know this, it is worth mentioning, again and again if need be, for the sake of the too many of us who do not; for the sake of those who do not know that there are well over 1,000 homes in Marlborough built before the turn of the 20th century—of which more than a small few date back to the 17th century; for the sake of those who do not know that our ancestors are buried in some of the cemeteries in Marlborough, some of whom were laid to rest 100 years before the American Revolution; and for the sake of the children who might be growing up without a full appreciation of history—not a history that is read in textbooks about long-ago, faraway places but a history that is right here before them, a history that they can touch, smell, and feel.

The old wood-framed houses, the weather-smoothed gravestones in the ancient cemeteries, the monuments and statues, the historical records and photographs, and the ever-vanishing open pastures and fields tell our story. They are maps and records of our past, tales and lectures of our greatest hours and our worst mistakes. They come to life as we explore them. They teach and explain, inform and advise.

Take a walk with me through a period of this old Colonial farm town that was destined to become a city. This walk through pictures and words, the pictures thoughtfully compiled and the words eloquently written by fellow historian Susan Alatalo, speaks of our past, our present, and our future. At its end, I hope you too find the importance in all that has passed before us. I hope you too find the resolve to preserve it, protect it, and tell our children of it.

—Richard Wilcox, curator
Marlborough Historical Society

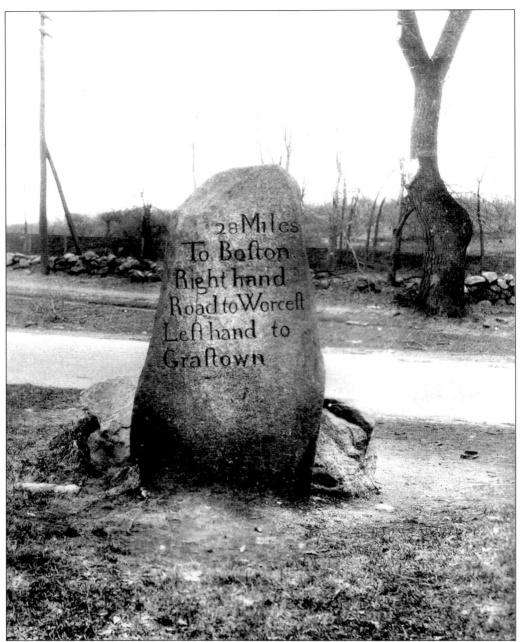

A COLONIAL POSTAL METER. Granite post markers, such as this one at the intersection of Boston Post Road, Walker Street, and Mill Street, were carefully laid out by Benjamin Franklin, postmaster of the Colonies (later postmaster general) to aid in the delivery of mail. These milestones made it simpler to figure distances and routes so that recipients of letters could pay the horseback rider or stagecoach driver a fair sum. Much of Route 20 follows roughly the same route as the old Boston Post Road. One segment that does match is the dirt road immediately in front of Longfellow's Wayside Inn, whose first owner, incidentally, was one of the original 16 petitioners for the creation of Marlborough.

One

A COUNTRY
KIND OF CITY

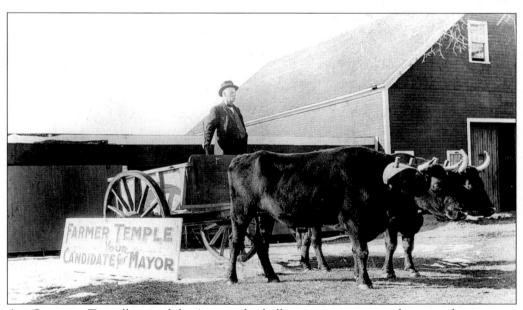

AN OXCART. To pull a candidate's cart, the bulls are wearing a wooden oxen bow, now a familiar barn decoration. Another great image of oxen is sculpted on the Henry Knox Trail marker located in Charles Bartlett Park, which is opposite the senior center on Main Street. Shown in bas-relief are these agricultural beasts of burden dragging cannon-laden sledges over frozen, muddy roads during the harsh winter of 1775–1776 by Gen. George Washington's artillery chief, Colonel Knox. Fifty-six granite markers trace the historic trail from Fort Ticonderoga, New York, through Marlborough and into Boston, where the British were overpowered and evacuated on March 17, thus determining the outcome of the American Revolution.

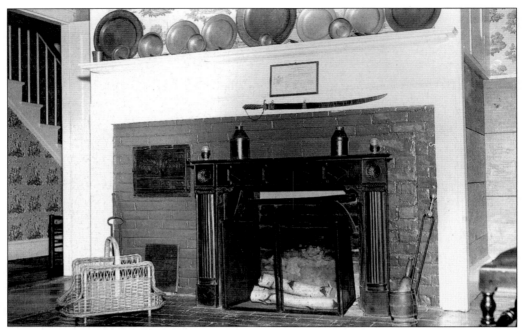

THE STEVENS HOMESTEAD, STEVENS STREET. In late Colonial times, a well-off family's hearth might look like this, but the Stevens family actually began building this home in 1708 with 11-inch square oak beams. Pewter plates, a beehive oven, and a mortar and pestle were used then. Before a fire left nothing but the chimney standing, Broadway actor Morton Stevens lived here. He was in Marlborough's American Legion Drum and Bugle Corps, as well as on television.

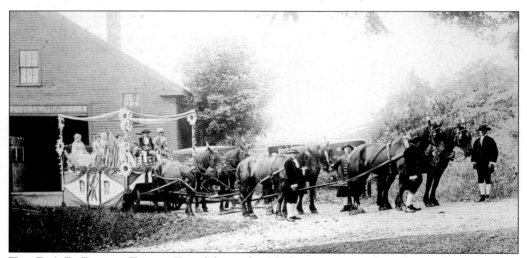

THE D.A.R. PARADE FLOAT. To celebrate the 250th anniversary of Marlborough in 1910, the Daughters of the American Revolution (D.A.R.) joined a parade and decorated a cart drawn by six horses, behind which can be seen more contemporary vehicles. Marlborough's Gen. Joseph Badger Chapter was founded in 1897 by Hattie Manning, its first regent and a descendant of Badger. By 1952, the only charter member still living was Clara M. Howe. New England barns often include a "door light," as shown here, a long horizontal window of small glass planes placed over the large door.

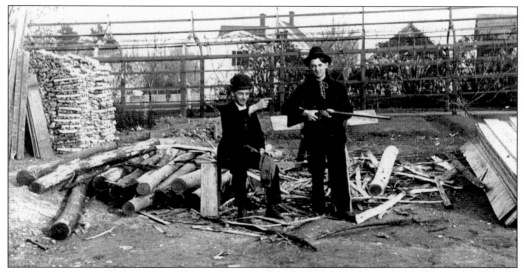

SHOOTING IN THE WOOD PILE. Brothers George and Adolph Lizotte are too close to residences near Frye Street to be playing with a gun and rifle under today's laws, but a Marlborough photographer, Prevost, shot this picture at the turn of the 20th century. Wood was used for heat, as well as constructing fences, homes, railroad ties, signs, utility poles, factories, shoe benches, shoe lasts, and shipping crates. (Courtesy of Kathleen Lizotte Lynde.)

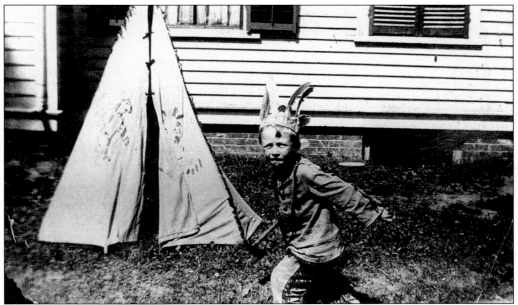

PLAYING INDIANS. On Commonwealth Avenue, Brave Francis Brown is dancing in front of a tepee decorated with a rearing pony. For the 250th anniversary celebration, the clothing store of Warren C. Blake and Company sponsored a float driven by an American Indian chief and advertising their Red Men collars. Ella Bigelow wrote, "A group of seven little Indian boys from the plains and hills of Sligo attracted lots of attention as they were carried about the city. The boys were afterwards presented with the Indian suits they had worn." (Courtesy of Dick LaFreniere.)

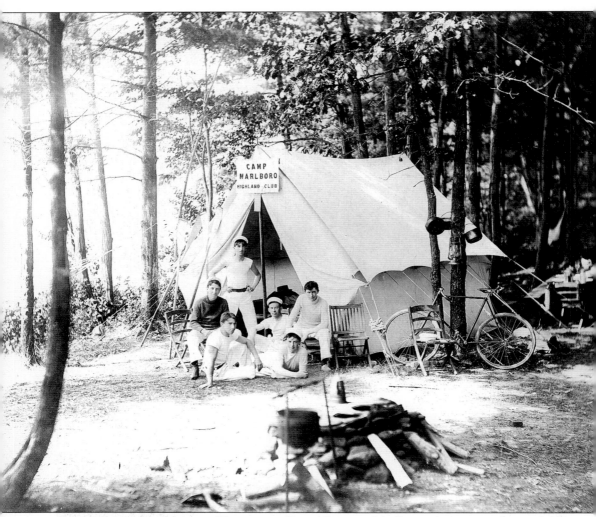

CAMP MARLBOROUGH, THE HIGHLAND CLUB. Because Marlborough is situated on a high plain between the Sudbury River Valley and the Assabet River, it is often referred to as the "Highland City." Only a small segment of the Assabet River runs inside city boundaries, but there are plenty of brooks, springs, ponds, and lakes. One of the young men outside of this tent pitched at Fort Meadow, or Indian Lake, as it was once called, is Charles Flynn. Normally, the Highland Club met at 116 Main Street at the turn of the 20th century.

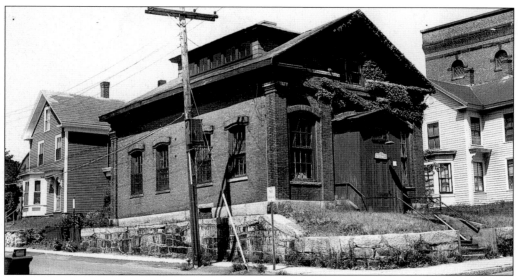

Marlborough's Natural History Museum. With the area's wealth of Native American artifacts, wildlife, botanical specimens, geological attractions, and intellectual curiosity, it is no wonder that there was a museum like this. Located at the corner of Gay and Mechanic Streets, this building was once the Marlborough Savings Bank and the First National Bank. Rosco Giles was museum director. The Natural History Society, along with D.A.R., participated in the city's 250th celebration by placing almost 40 markers at points of interest for visitors and residents.

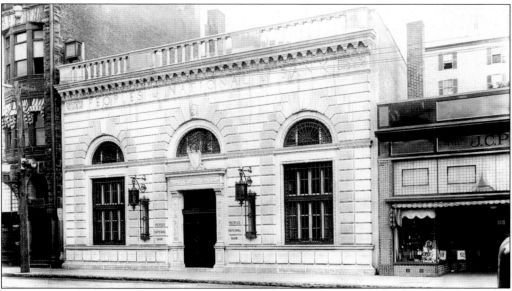

The Bank at 181 Main Street. A sculpted American Indian head is centered under the bank's name, near the top. A detailed bas-relief of tomahawks, quivers, bows and arrows, grapes, pumpkins, and squash surrounds the entrance. It was designed in 1926. King Philip, son of the Native American chief who welcomed Plymouth's pilgrims, waged war upon Marlborough's Colonial settlers. The scalp of a lame girl was found on hostile Native American's who had killed her near the Northboro border, where her remains are marked by a solitary grave with the name Mary Goodnow.

BLUEBERRY PICKING AT FORT MEADOW. Today, Fort Meadow Drive runs through this field on Round Top, but Elsa, Dick, and Rita Peters are still regular summer visitors from Florida. They are joined by many out-of-state vacationers. In existence since 1947, their Fort Meadow Association is perhaps the oldest neighborhood association in the area. It still owns a beach lot. (Courtesy of Richard W. Peters.)

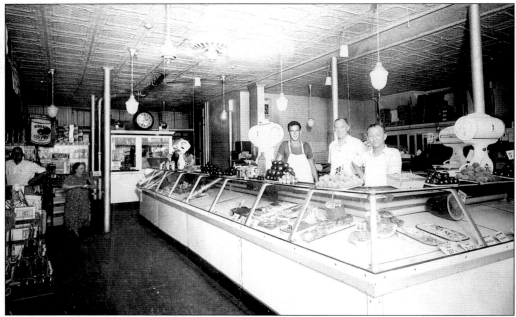

INSIDE GEORGE BOND'S MARKET. This store was at the corner of Main and Liberty Streets in the Boylston Building, in front of John King's Blacksmith Shop and next to one of two shoe plants owned by Samuel Boyd. Since the other plant was on the site of the Addison Building, cases of shoes were frequently pushed across Windsor Street from one factory to the other. From left to right at the counter are unidentified, Elmer "Mike" Holden (the owner's son-in-law), Wilson Walker, and the rest are unidentified. John Navin worked as a clerk here and Mike Desimone was the produce manager.

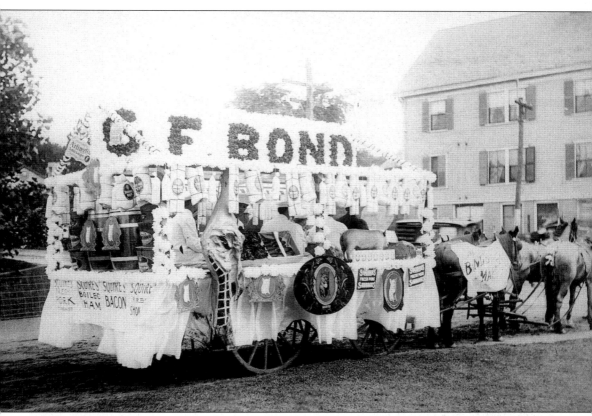

BOND'S MARKET FLOAT. Curing, spicing, pickling, and drying meats, fruit, and vegetables were ways to prevent precious foods from spoiling from hot weather, or from one brief harvest season to the next. Displayed on this 1920 parade float by G.F. Bond's Market are pickling barrels, sausages, and hams. This store began in 1902. Downey, Gauthier, Wellen, Frank I. Boule, and Mike Desimone were the names of owners of other markets.

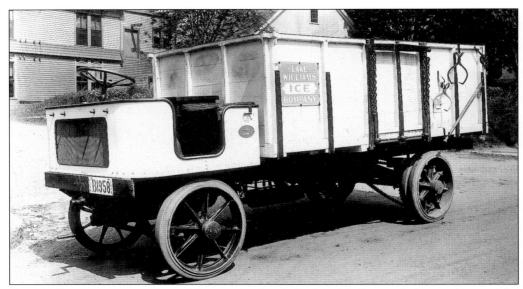

BEFORE REFRIGERATION. Several ice companies thrived in Marlborough due to the need for food preservation and the availability of suitable ponds and lakes for ice harvesting. Also used for milk deliveries, horse-drawn wagons were used to drop off ice to homes and businesses. Later, motor trucks, such as this one from the Lake Williams Ice Company, made deliveries. The tools hanging near the rear were used for hauling blocks of ice to houses that had ice placards placed in an window. This company was started in 1861 by J.W. Brigham.

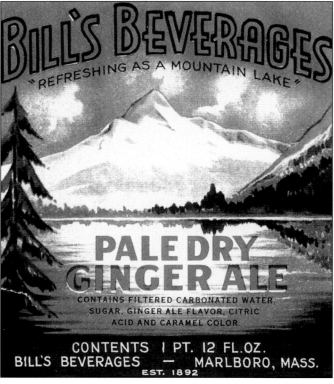

BILL'S BEVERAGES. This soda bottle label extols the fresh water this community has benefited from since the time of Native American inhabitation. A healthy spring is given as the reason why the early Ward family purchased land from the Praying Indians around Ward Park. Its water runs inside culverts under Main Street nowadays. Established in 1892, Bill's Beverages sold Moxie soda tanks and gas tubes from 336 East Main Street. Evelyn V. Bill was proprietor in the 1940s. Other local bottlers were J.E. Hayes & Company, M. Burke, F.S. Rock and Company, and Orange Crush Bottling Works, which used Millham Springs.

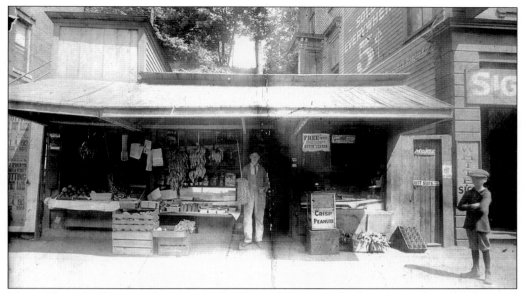

MARY HAYES'S PEANUT STAND. At the foot of the stairs leading down from Washington Court to Main Street was a popular stand that sold tropical fruit, which was transported via the railroad. One of Marlborough's three railroad stations was located nearby. Above the hanging bananas, as well as on the right, are signs promoting Moxie, an early soft drink. Posters on the far left advertise horse races at Marlborough's Trotting Park on the Fourth of July in 1913. The stand was taken down in 1933.

IN TAYNTOR'S WAGON. The girls sitting in front are Clarissa Wyman (left, who eventually married Georgie, the boy sitting behind her) and Myrtle Ladd. The young men from left to right are Stanley Freeborn, Warren Howe, Willie Ladd, Robert Bigelow, George Windsor Howe (seated), Hollis H. Tayntor, and Percy ? (seated). This photograph from a glass-plate negative was taken by Joseph Irving Tayntor, a farmer who lived at 120 Prospect Street.

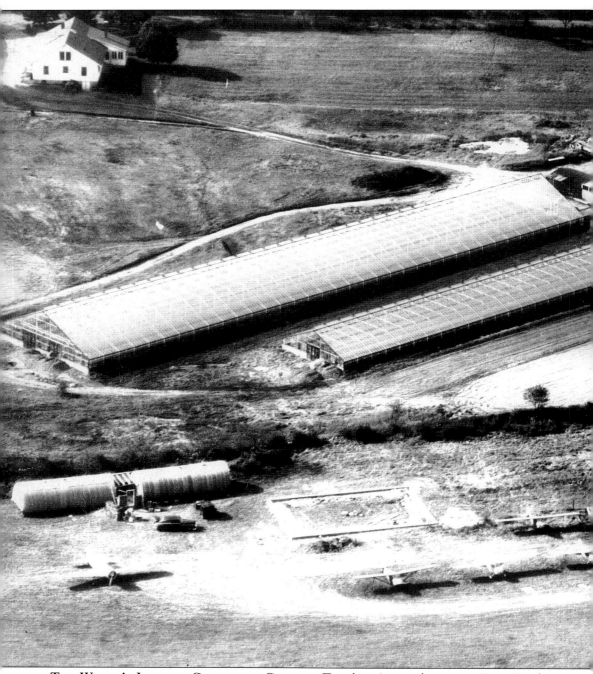

THE WORLD'S LARGEST CARNATION GROWER. Trombetta's greenhouses on Farm Road no longer produce the volume they peaked at, but the variety of offerings today make it the spot to stop for ice cream, lunch, children's activities, garden statuary, and growing tips. In the lower portion of this aerial photograph is a rudimentary Marlborough airport, the oldest privately owned commercial airport in New England. Planes were landing here as early as 1922. Contractor Francis Kane built the main hangar. In 1946, Donald Lacouture and Antonio Nunes

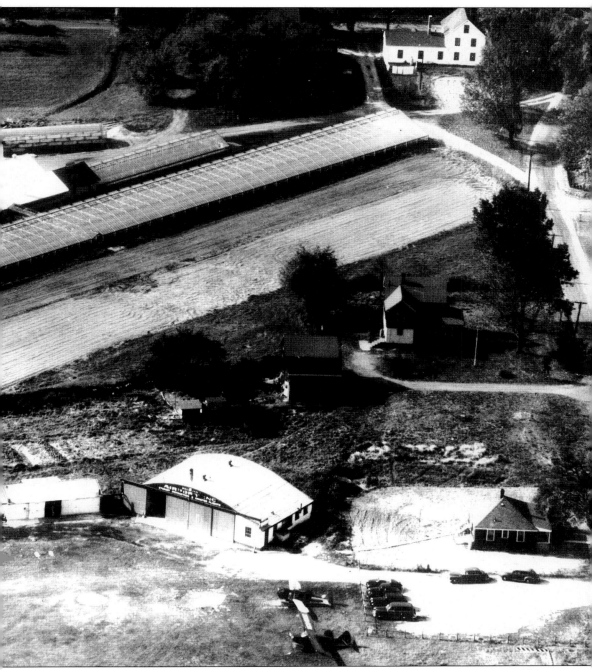

purchased the airport and Don's Flying Service began. Franklin D. Roosevelt's grandson, film actress Ruth Chadwick, and bandleader Vaughan Monroe, who owned the Route 9 nightclub the Meadows, all took flying lessons here. A wood-paneled wagon is parked closest to the photographer, Walter Davenport. Broadmeadow Road runs horizontally across the top of the scene, with a corner of the Southborough Reservoir in the upper right hand corner. (Courtesy of Trombetta Family.)

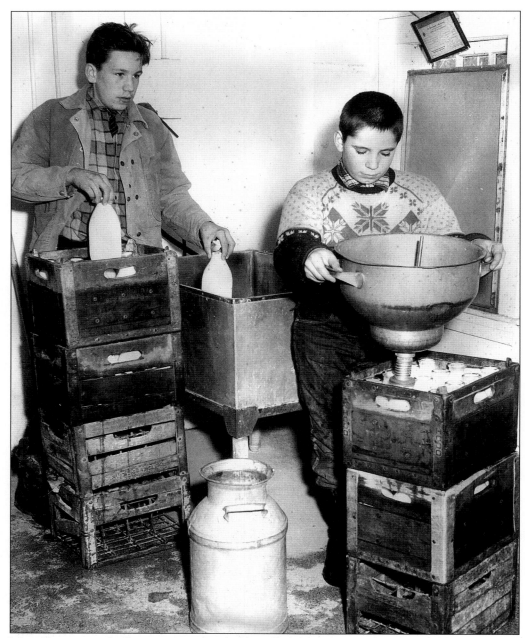

MILK BOTTLING. In front, a container holds milk from cows raised at the Hillside School on Robin Hill Road. The school's philosophy includes physical work necessary for maintaining its farm. When the Wachusett Reservoir was created in 1927, Hillside's original location was flooded, so the school moved to the 350 acres of Bowler Camp, an estate with cottages, pastureland, and an artesian well. Cows have been kept locally since early Colonial times. Other local dairies were Marlboro Dairy, Better Dairy Products, H.L. Duplessis Dairy, Star Dairy, Charles Jaarsma, Lizotte's Dairy, Elmside Farm, Labelle Farm, and Brightwood Farm.

Two

AT WORK IN
HIGHLAND CITY

K.D. CHILDS'S BAKERY.
Horse-drawn sleds delivered
bread in the winter. Kellogg
D. Childs was one of a few
bakers listed in *The 1887-8
Marlborough and Hudson
Directory*. This photograph
was taken by M.H. Albee, of
Central Street, with a
stereoscopic camera.
Stereoscopic photographs are
made when two slightly
different images are taken and
then printed side by side on a
stiff card, which is placed in a
viewer. The stereo viewer or
special glasses are used so that
the image will appear to have
three-dimensional depth.

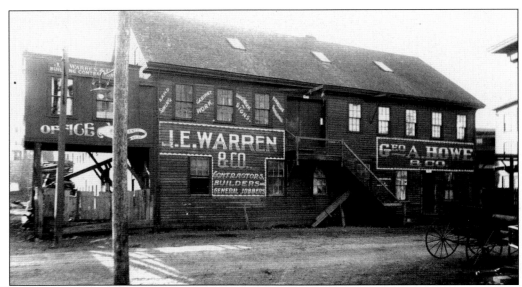

J.E. WARREN WOODWORKING MILL. Unlike Europe, early New England had plenty of trees, and a growing Marlborough had many uses for lumber. J.E. Warren, a building contractor, was located by Monument Square in 1887. Howe Lumber Company began in 1860. George A. and A.B. Howe were dealers of lumber, doors, sashes, and blinds. Later located by the old Colony Depot on Florence Street, these businesses helped the building boom, of which trees played an integral part. (Courtesy of Marlborough Public Library.)

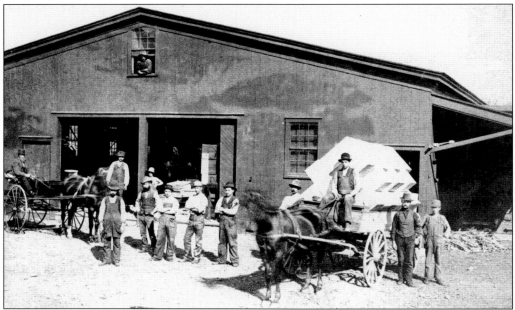

JOSEPH MANNING'S LUMBER MILL. Also based close to the railroad, a lumber mill located at 11 Manning Street off Mechanic Street is shown in this stereo view. In the *1870 Marlborough Directory,* the owner is listed as E.F. Longley, whose son prospered as a box manufacturer, producing 15,000 boxes a month. Knife grinding, planing, and sawing services led to a thriving trade maintaining large shoe-factory machinery.

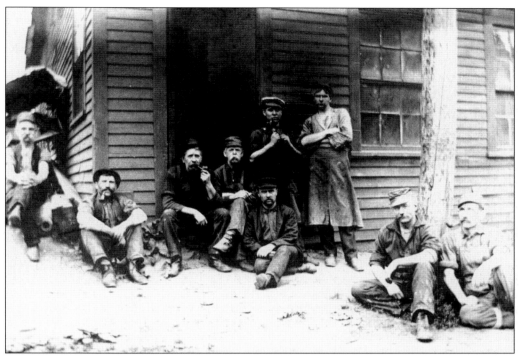

PARSONS MACHINE SHOP. Gen. Henry Parsons and his son were machinists and iron founders. They produced steam engines, hot water heating, and elevators, as well as boot and shoe machinery from their business on Lincoln Street.

THE STATE ARMORY, 164 LINCOLN STREET. Next door to Parsons, on the contemporary site of the State Armory, was what may have been a corset shop at 164 Lincoln Street. Seated somewhere in the front row are Adelina Vigeant Denoncourt, Miss Boudreau, and Miss Levielle. Included in the second row are Mrs. Belmore and, at far right, Mrs. LaFleur. In the third row are Mrs. Mercier and Mrs. Granger.

F.S. ROCK & COMPANY. At Rawlins Avenue and Main Street was the home of Dr. John Rock's father, which was next to the family business. The business advertised itself as "Bottlers of Ginger Ale, Nervine, Root Beer, Soda, Etc." Later, the Rock building housed the Marlboro Theater, which is no longer standing. John Rock's father also owned a horse racetrack at what is now Ghiloni Park. While researching infertility, Dr. Rock, a devout Roman Catholic and a twin, developed the birth-control pill.

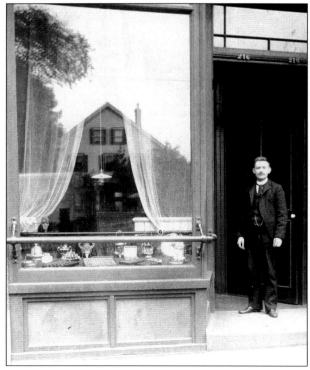

OPENING DAY AT 216 MAIN STREET. Jeweler Harry O. Barthelemes opened his shop in 1888 at 216 Main Street, and it remained at the same location until his death in 1942. His jewelry store and watch repair shop were on the Middleton Block, which is now listed on the National Register of Historic Places. Raymond C. Whitney was the clerk. Reflected in the store window is the house across the street where Dr. Rock, inventor of the birth-control pill, grew up.

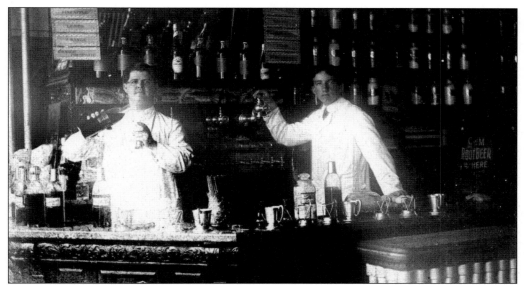

F.B. MORSE'S DRUG STORE. Willliam Williams and F.J. Coyne prepare bromides, sodas, and other soothing concoctions in July 1905 at F.B. Morse's Drug Store, located at 112 Main Street. Druggist Fred Morse resided at 15 Warren Avenue.

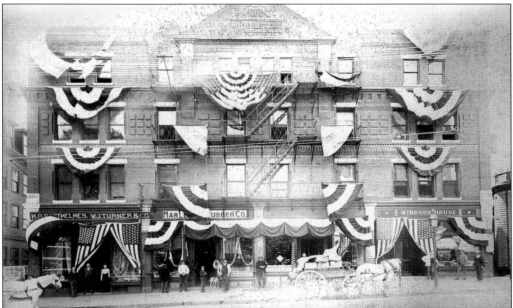

THE MIDDLETON BLOCK. Even in the new millennium, this building is recognizable with its name high at the top. The decorations in 1910 were for the 250th anniversary celebration of the town's founding. The jeweler is standing in his doorway, which also leads to W.J. Turner and Company, a bakery. Ed Barnard, proprietor of the Marlboro Rubber Company, is wearing shirt sleeves and standing to the right of the dog on his stoop. William Hefferon, the barber, is standing next to his striped pole behind the wagon. Next to his shop is a lunch room run by Jim Mitchell. The Windsor House, owned by Louis Houde in 1900, occupied the top three floors with an office and smoking room.

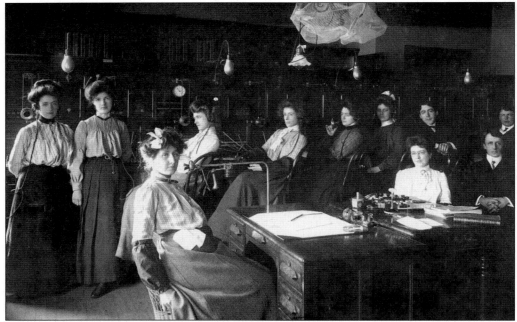

THE COREY BUILDING 1903. Laura Brown turns toward the photographer from her desk. Wearing glasses is bookkeeper Bessie Barry. Next to her, holding his hands, is the manager, Ralph Walker. Later, Walker worked for AT&T and the New York Telephone Company. Pausing from the switchboard, but still attached, are, from left to right, Ruby Angell, Georgia Clarke, Eleanor Powers, Lina Hemenway, Mable Dorkendorff, Lillie Maddox, Fred Cole (the night operator), and Charlie DeHunter (the trouble man).

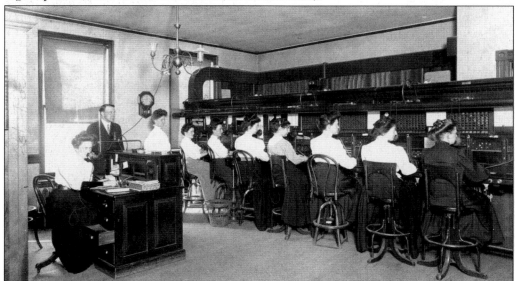

SWITCHBOARD OPERATORS. The supervisor on the left speaks through her device to any of the operators who must manually plug in connections for telephone calls. Rules for dress and behavior were rigid. Permission must have been granted before leaving for the restroom, located on the left of the room.

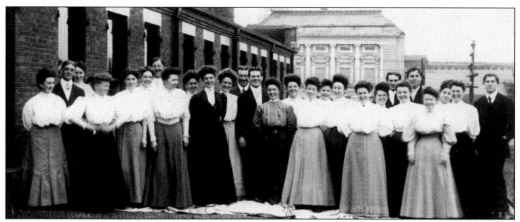

DOWN FROM CITY HALL. These telephone company employees are on the roof of the Corey Building, most likely, or another Main Street building located west of city hall, seen in the distance. Tom Ewart (center) is the lucky leader of these predominantly female switchboard operators who are giving him a going away party in 1906. Mary Williams, Myrtle Wallace, Mildred Wiles, May Powers, Frances Chisholm, Nora Wade, Helen Reilly, Nellie McCabe, and Blanche McCarthy are listed as employees in 1916. Beneath the telephone company offices were two stores: Grant's and Woolworth's.

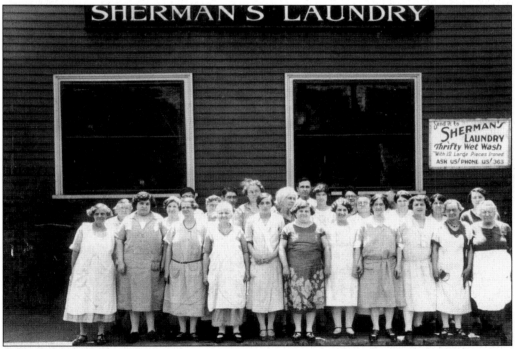

SHERMAN'S LAUNDRY. The increasing workforce needed nice fresh clothes, so washing services were in demand. This launderette was located at the corner of Maple and Main Streets. Edward C. Ledoux donated the photograph to the historical society's archives. According to historian Ella Bigelow's description of the 1910 parade, Sherman's Laundry presented a beautiful float. There were three laundry teams and a four-horse float carrying ten girls dressed in pure white and decorated with more than 1,000 red, white, and blue paper flowers.

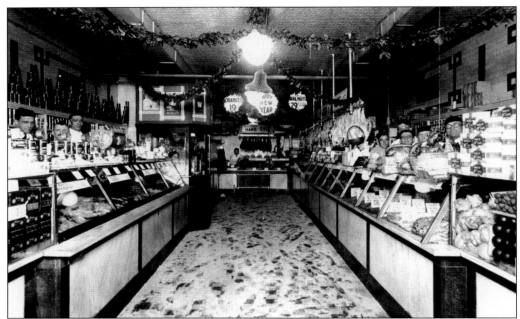

FRYE'S MARKET. This Main Street shop was located near Sherman's Laundry. Amos Percy Kimmens is near the hanging basket on the right. It is approaching New Year's c. 1932. Swordfish, haddock, ham, bacon, walnuts, cake, and oranges are just a few of the items in stock.

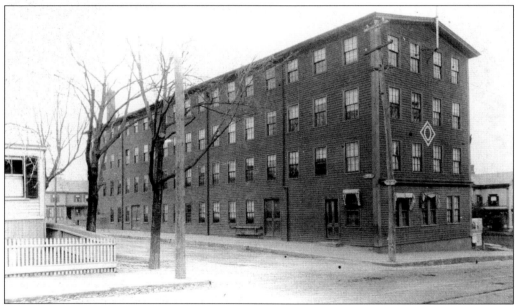

THE FUTURE KOEHLER PLANT. Carbide lamps were used in coal mines in 1900 but only where no gas was suspected. In 1912, Ernest Koehler, a German immigrant, founded the Koehler Manufacturing Company to manufacture safer mining lamps that would just flare and not explode deep in the mines. He took over this space, the B.F. Corbin Diamond O. Shoe factory on the corner of Howland Street. (Courtesy of Marlborough Public Library.)

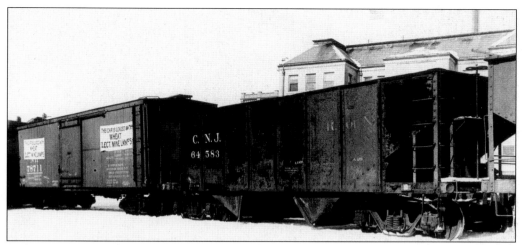

SHIPPING MINER LAMPS. Behind the freight car is the rear of city hall. In the winter of 1924, four freight-car loads, like these, were shipped to a coal company in Wilkes-Barre, Pennsylvania, loaded not only with a local product but also a local invention. Koehler Manufacturing produced the various Wheat lamps, and Marlborough's own Grant Wheat designed them.

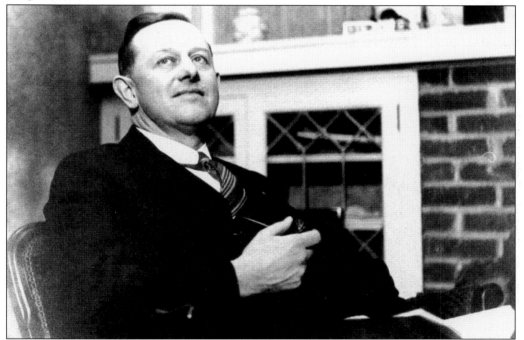

GRANT WHEAT ON A BUSINESS TRIP. Grant Wheat, the inventor of the miner lamp, traveled to England in 1947. In 1917, the scientist was offered a fully-equipped laboratory at Marlborough's Koehler Manufacturing Company. He created a battery-operated electric lamp and other valued patents. His original Wheat lamp is in the Smithsonian Institute. At the time of this portrait, the only other electric cap lamp approved by the U.S. Bureau of Mines was the Edison Electric Cap lamp, manufactured by the Thomas A. Edison company of West Orange, New Jersey. Wheat died in 1955 and is buried in Maplewood Cemetery.

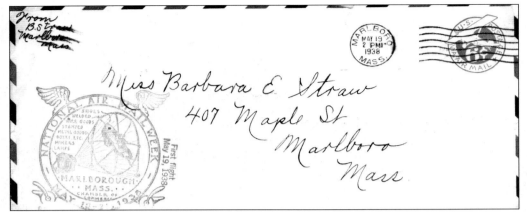

AIRMAIL. For 6¢, Barbara (Straw) Somerville's mother, Blanche Straw, sent a letter flying from Marlborough Airport in 1938. The typically red-and-blue edged airmail envelope has preprinted orange postage and a sky blue postmark, showcasing the goods Marlborough is known for. Tiny arrows point to the corresponding icons: shoes, welded wired goods, stamped metal goods, boxes, and miners' lamps. Postmaster Carl Rowe ensured that the letter was delivered to the Maple Street home, now gone, where the three Straw sisters grew up. (Courtesy of Barbara Somerville.)

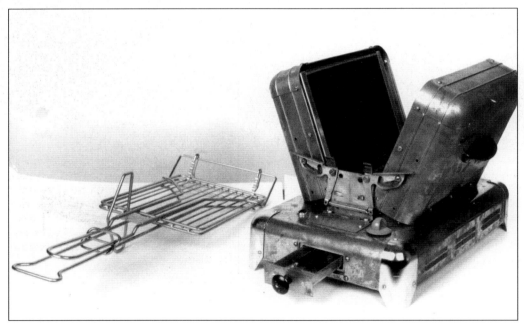

MARLBORO WIRE GOODS. When Hector E. Moineau purchased a small business in 1906, laundry drier parts and heavy, gas-heated flat irons for tailoring were produced. Over the past century, the company has manufactured electric lamp guards, fan guards, eight-millimeter Labelle bullets, caliber armor piercing cores, kitchen utensils, enameled wire bathroom fixtures, wire carrier supermarket baskets, display racks, and shoe factory equipment, such as sole racks and trays, box toe holders, upper holders, tag holders, and wooden heel clamp screws.

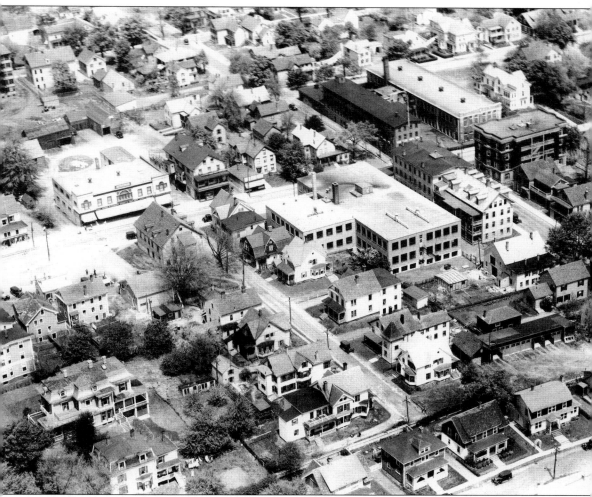

AN AERIAL VIEW OF HOWLAND AND LINCOLN STREETS. The location and name of the Moineau family's company have changed many times. In 1909, the business was in the Johnson Claflin Corporation's building on Lincoln Street, where it was called Electro-Weld Company. Marlboro Products Company and Marlboro Metal Work were other names. In 1921, the manufacturer moved to the old Rice and Hutchins Building on High Street. Products were distributed through S.S. Kresge Company, S.H. Kress and Company, and F.W. Woolworth Company. Hector Moineau was the wire inspector from 1910 to 1920. Koehler Manufacturing occupied the long grey building with four levels of windows.

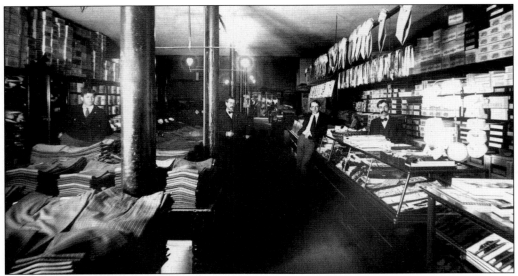

N.H. RANNEY CLOTHING AND FURNISHINGS. In July of 1902, this clothier was located at 59 Mechanic Street. At the far left is store clerk Bert Mitchell. Like other prosperous downtown merchants, Nathan Ranney resided in a large Newton Street home on Fairmount Hill.

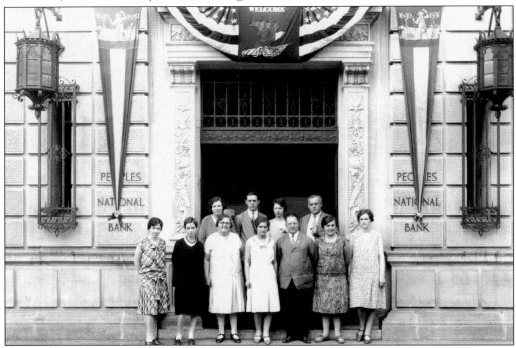

THE PEOPLES NATIONAL BANK. The Peoples National Bank opened in 1878. It was once located inside the old town hall before it moved across the street in 1881 into the Temple Building at 175 Main Street, the space the Marlborough Cooperative Bank later took over. These 1930 decorations are for a 300th anniversary. Although the metal lettering on both sides of the entrance is gone today, its indentations in the cement bricks are still visible. A bank still resides at this location, one with exquisite interior décor as well.

A ONE-OF-A-KIND AUTO. On Winthrop Street, a few miles away from Henry Ford's estate of the Country Store, Little Red Schoolhouse, Wayside Inn, and Wayside School for Boys, O.D. Wheeler and his son O.E. Wheeler designed and built this prototype for a one-cylinder model, which was never mass produced. After failing to secure financing for the Wheeler Runabout in 1902, the disappointed designers put this unique vehicle in storage for 50 years. It has five horsepower, two speeds for forward driving, and two speeds for reverse.

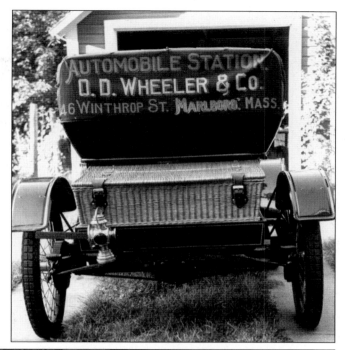

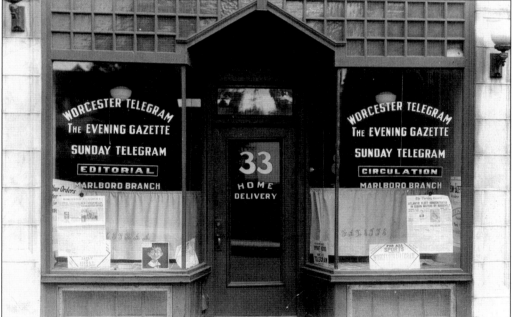

A MARLBOROUGH OFFICE. "Telegram Gazette" in all capital letters is embroidered on the curtains of this local office, once sited close to where the current *Marlborough Enterprise* and *MetroWest Daily News* is today, in the old post office building. Take note of the "What-me worry?" portrait of Alfred E. Neuman of *Mad*-magazine fame in the lower left-hand corner of the window. As of April 1956, the *Mad* mascot had not been officially adopted, but the face appears as far back as the early 1900s. (Courtesy of Kathleen Lizotte Lynde.)

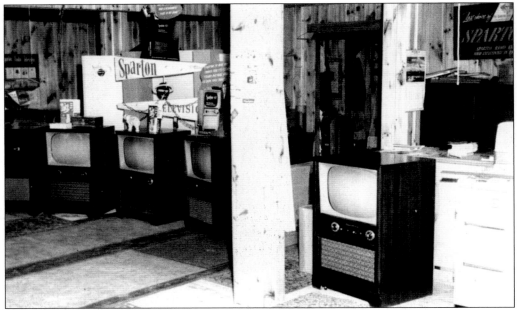

THE SOUTH STREET TELEVISION SHOP. In 1953, LaFreniere's Television Center moved from Main Street to this location, and antennas were necessary to view any television shows. In the beginning, there was no cable, no color, no remotes, and no satellite. There were few rabbit ears. Most homes had to have antennas installed. Marlborough's 10 channels were 2, 4, 5, 7, 9, 10, 12, 25, 38, and 56. (Courtesy of Dick LaFreniere.)

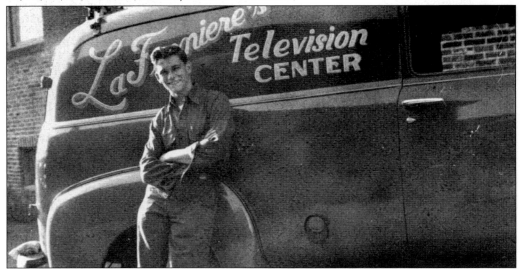

THE FUTURE DICK AND RON'S TELEVISION. Ronny LaFreniere was barely a teenager when his father, Arthur, began the family appliance repair service (later called Dick and Ron's Television) at 45 Bolton Street *c.* 1944. This photograph was taken in 1950 by Ron's brother Dick, when the store became an exclusive Sparton Sales and Service Dealer and moved to 128 Main Street, where Joseph's on the Main is today. Hundreds of the No. 4940 model were sold, a 10-inch mirror reflective console. Color television began in the 1960s. (Courtesy of Dick LaFreniere.)

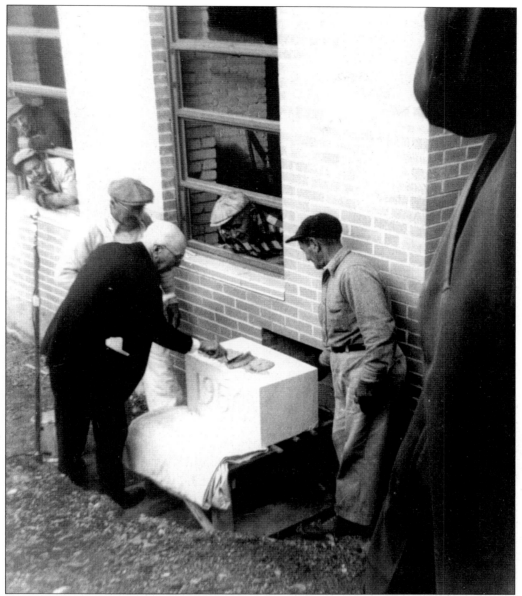

DOCTOR SMITH AND THE MASONS. The cornerstone for a new addition to Marlborough Hospital was laid on November 9, 1950, by Dr. C.W. Smith, "dean of Marlboro physicians." A copper box containing pictures and articles on the Hospital's history was placed in a slot located at the addition's southwest corner. More than 100 people attended the exercises led by attorney Paul F. Shaughnessy. Mayor Carlton W. Allen offered congratulations on behalf of the city. (Courtesy of UMass Memorial Marlborough Hospital.)

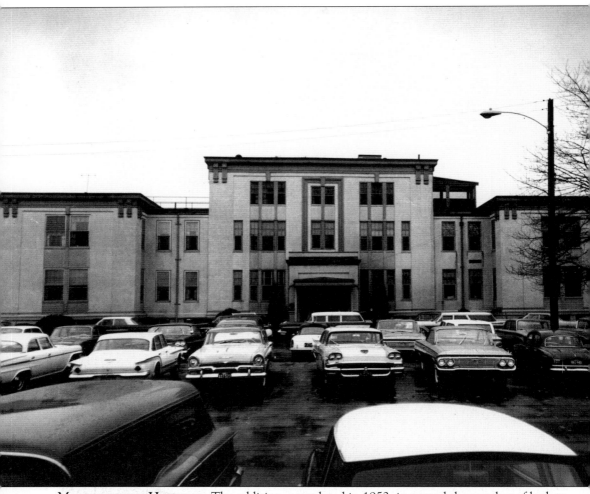

MARLBOROUGH HOSPITAL. The addition, completed in 1952, increased the number of beds to 103. In 1893, the hospital began in Rev. Sylvester Bucklin's house on Hildreth Street, thanks to Dr. E.G. Hoitt's suggestion. Hannah E. Bigelow, a doctor, was the founder. The hospital was incorporated in 1890. To raise funds, the Marlboro Board of Trade and Trustees of the hospital held a Labor Day barbecue at the Marlboro Driving Park in 1904. Featured speakers were visiting governors and mayors. By 1913, there was enough backing to open a cement, stucco hospital on Union Street, where the medical facility is still located today. It looks much different than in this *c.* 1960 photograph. Funds for laboratory facilities were provided by the Ford Foundation in 1957. (Courtesy of UMass Memorial Marlborough Hospital.)

Three
RUNNING CENTER CITY

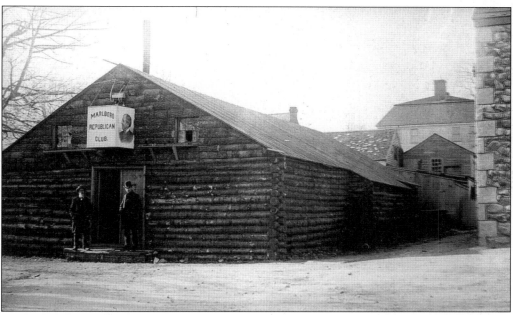

EARLY REPUBLICANS. Benjamin Harrison and Levi P. Morton were presidential candidates in 1892. In contrast to the fanciful Queen Anne-style architecture of the First Baptist Church, this log cabin used to be on Main Street (Route 20) almost touching the church's corner. The interlocking technique of joining perpendicular logs to construct solid houses saved many early Colonists' lives from unfriendly natives, hostile weather, and ferocious carnivores. Probably brought to Jamestown in the early 1600s by explorers from Finland and Sweden, the log cabin style has become synonymous with early American wilderness. However, this cabin is in 1892 in Monument Square. It is the Marlboro Republican Club's temporary headquarters. When the temporary clubhouse for local Republicans was torn down, the Spanish-American War Memorial was placed here.

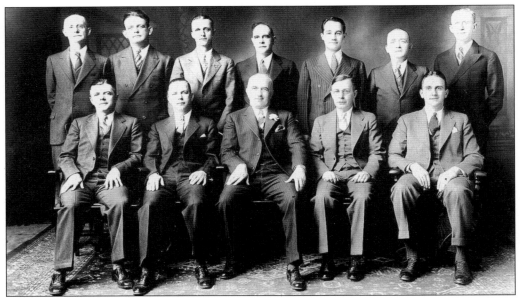

1934 CITY COUNCIL. From left to right are the following 1934 city council members: (front row) Arthur Kelly, Romeo Gadbois, Charles Lyons, Harry Cole, and Carl Craig; (back row) Michael T. Burke, George Mahoney, Alphonse Lafleur, Albert "Stubby" Bergeron, Edward Bigelow, Robert Burns, and Michael Cronin.

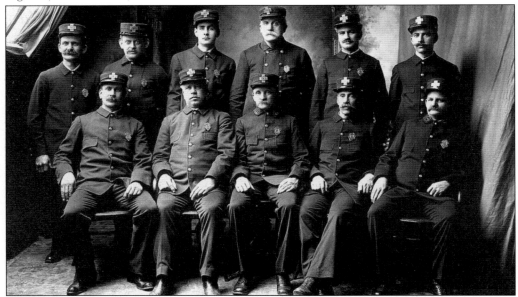

EARLY FIREMEN. In a flourishing shoe town with numerous multi-level factories, the need for capable fire rescue was obvious, even as early as 1825, when a few private individuals began plans for procuring an engine. When town funds were allocated in 1845, the monies could be used for equipment purchase only. Annual salaries of $3 were not granted until 10 years later. Shown, from left to right, are the following: (front row) Albert Perry (clerk), Bert Adams, Charles T. Berry (captain), Joseph Aldrich, and Fred M. Hayden; (back row) Herbert Bartlett, Harry Perry, William H. Hogan, C. Harry Bonner (driver), Franklin G. Taylor, and Ernest Howe.

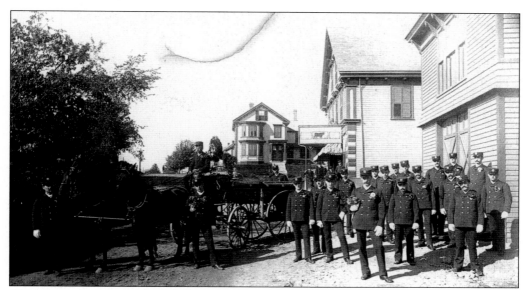

1888 HOSE COMPANY. The Marlborough Hose Company No. 4 is standing outside its firehouse on the right. This is Francis Street. In the background is the house where the Rappaport and Shapiro families lived. Ryan Court is in the corner.

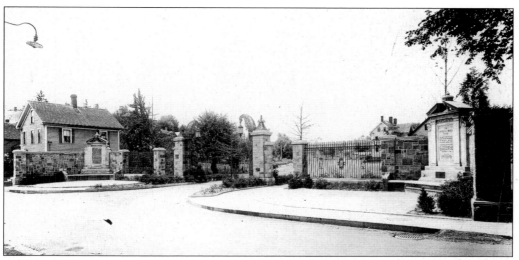

WARD PARK'S ENTRANCE. The city's first municipal playground is named in honor of Gen. Artemus Ward, who was the commander in chief of the Colonies in 1775. William Ward, grandfather to Artemus, built a garrison house near the first Marlborough church. Later, the Wards moved to nearby Shrewsbury, where Artemus's birthplace is a historically recognized homestead. Generations later, another Artemus Ward donated funds for a Marlborough park with an ornate gateway in remembrance of the land called Hayden Field that his family settled on in early Colonial times. Ward Park's elaborate entrance was originally erected closer to Main Street but then was placed a distance away from the major thoroughfare of Granger Boulevard. This is Windsor Street. The view looks toward Liberty Street. Plans for Ward Park began with Mayor Edward T. Simoneau and continued when James M. Hurley came into office.

MAIN STREET BY MONUMENT SQUARE. This early view looking toward the business district shows what will become the intersection of Granger Boulevard, Main Street, and Mechanic Street. The Soldiers Memorial is recognizable on the far left behind the boy. A much taller steeple on the Immaculate Conception Church is barely visible above the trees. The trolley tracks run over the dirt road. Otter Tayntor used a glass plate for this photograph. He coated it with a light sensitive liquid before exposing the picture.

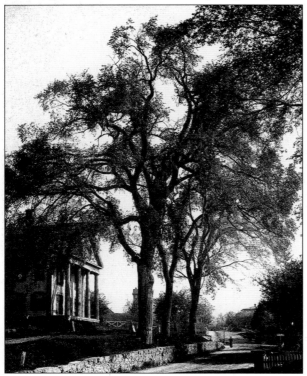

EARLY EAST MAIN STREET. Roads used to look like this. On the far right is Middlesex Square, and the old fire station's tower is barely visible behind the largest tree in the foreground. A woman is walking on the road by a street lamp. In 1802, this home, which is still standing, was known as the John Stowe place. Samuel Stowe was John's father, and he arrived in Marlborough before 1684. Later, the house was called the William Stetson Homestead. Deacon Stetson was a contemporary of Amory Maynard, a Marlborough boy whose industrialism compelled a nearby town to be named after him.

MARLBOROUGH JUNCTION. C.M. Angier's residence here was south of the intersection of Mill and Brigham Streets. After 1893, a new car barn for the trolley was built and the tracks were extended south on Maple Street to the steam railroad station. These split tracks were captured in a stereo view by J.C. Richardson and given to the Marlborough Historical Society before 1968. Good transportation has been a key to Marlborough's economic success, and early shoe manufacturer Samuel Boyd knew it. Three years after electricity was installed in Marlborough, the first street railway began; it was only 1888. Not many communities could boast having three railroad stations and trolley service. Between the Marlborough Street Railway and the Framingham, Southboro, and Marlborough Railway, there were 22 miles of routes.

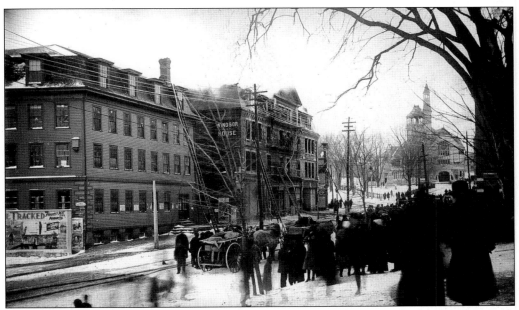

FIREMEN IN ACTION. The Windsor House still stands today, so apparently this fire rescue was a success. Its logo is visible on the side, painted on the brick. This block is located on Main Street across from today's Walker Building. Monument Square is recognizable in the distance. Beginning in 1889, horses drew fire engines to the smoky scenes. The hose is twisting up the front center of the Windsor House, where there are firemen on ladders. Local 1853 fire regulations prohibited the possession of "any Rocket, Cracker, Squib or Serpent."

41

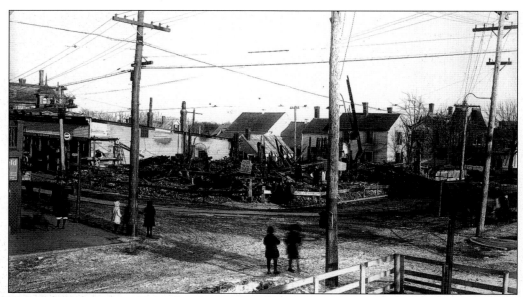

THE ST. JEAN BLOCK FIRE. On the corner of Lincoln and Broad Streets, the French Hill community building was leveled by fire on January 3, 1873. This view is looking southeast. The French-speaking population had held dances and other social events there. Local fire laws in 1853 state, "When an Engine shall be at a fire without assistance or the means of procuring water by suction or a line of Engines, the Company will endeavor to procure water by means of buckets, or otherwise, and strive to keep the fire in check until a constant supply can be had."

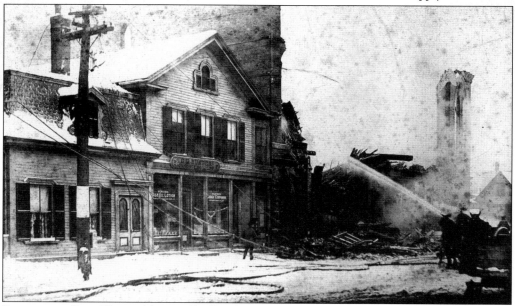

BURNED IN CITY HALL. Almost all official records, city correspondence, U.S. mail, furniture, statuary, paintings, and library books were lost in 1902, when a fire devastated the old Victorian Gothic-style hall, despite the very cold and icy weather. Next door was C.D. Hunter Drug Store and Harry Hunter's private dwelling. On the other side of city hall is the old New York, New Haven, and Hartford Railroad Station, or the Old Colony Railroad Station.

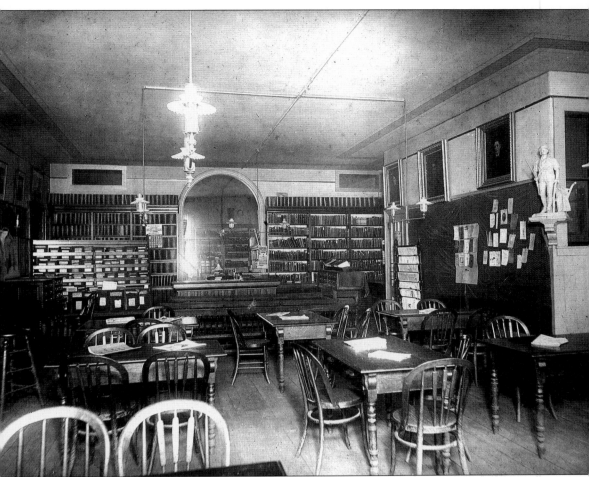

LIBRARY RESEARCH. Following the Christmas-night fire of 1902, only 400 volumes from the library were saved from the ruins and rebound. However, a few of the old, thin catalogues remain in the library's archives. On the far right is a three-foot miniature of Daniel Chester French's "The Minute Man," purchased by Hannah E. Bigelow in memory of her father Levi. There were four minutemen companies from Marlborough. About 190 men, more than one-eighth of the community's population, responded to fight British troops in the American Revolution. (Courtesy of Marlborough Public Library.)

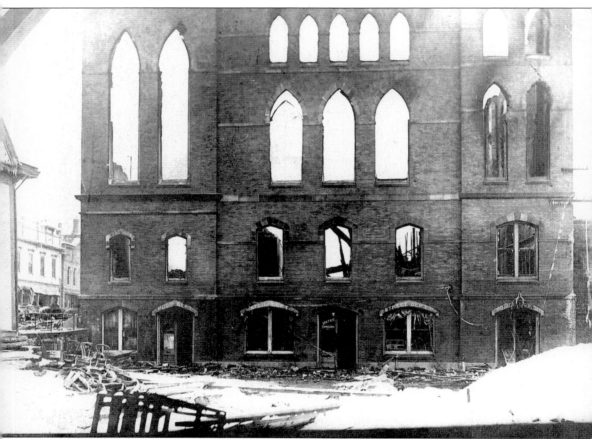

OLD CITY HALL RUINS. On Christmas night in 1902, a fire burned down the building that contained not only local government offices but also the post office, public library, Peoples National Bank, headquarters of the Grand Army of the Republic (G.A.R.) headquarters, armory, Nolan's Store, Hammon's Store, and, as one can see from the side of the building, the poor department, water department, street department, and police department, including a court. The horse and sleigh belong to the fire department, which was located off-site. (Courtesy of Marlborough Public Library.)

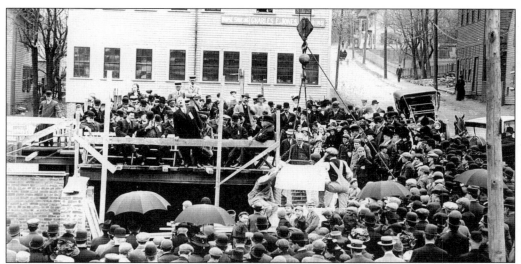

LAYING THE POST OFFICE CORNERSTONE. Also without a home since the 1902 city hall fire was the post office. Finally, construction of a Renaissance Revival-style building at 24 Mechanic Street began at the corner of Gay Street. Sandstone from Cleveland was used on top of a granite base from West Chelmsford quarries. The terra cotta roof was covered in tin. Both electric and gas fixtures lit the building. This ceremony began at 1:30 p.m. on Wednesday, April 19, 1911. The plainly inscribed cornerstone is still visible today, although the post office is no longer housed here. At the ceremony, Charles W. Curtis read a list of articles in the box deposited inside the cornerstone. The postmaster was John Sawyer Fay (1840–1914). The Honorable John J. Shaughnessy, mayor from 1910 to 1911, is standing in the center of the platform with a dark suit and white tag. Attorney Shaughnessy was a Democrat.

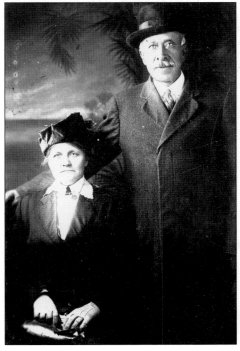

A RETIRED MAILMAN IN FLORIDA. Henry Dupuis married Charles Lizotte's sister Belzemier. Because Dupuis could speak French, he was appointed by postmaster Fay over someone else with seniority on August 18, 1887, to replace one of the four original letter carriers. He died in 1939. Established in 1799, the Marlborough post office was located at 47 East Main Street, in the Hemenway House. Before that, Worcester was the nearest place to receive mail. Joseph Brigham was the first postmaster to be situated in the Hemenway House. (Courtesy of Kathleen Lizotte Lynde.)

THE GREAT HURRICANE OF 1938. These cement sidewalk squares have been torn up by the roots of a large tree that was blown over by the Hurricane of 1938, which devastated many New England towns and cities. This is West Main Street, where a number of the homes were owned by physicians. The public library is a short distance down the street on the right. (Courtesy of James and Jean Durand.)

THE IMMACULATE CONCEPTION CHURCH WITHOUT A STEEPLE. Standing across Main Street from where Delaney's Newsstand and Escargot Thai restaurant are today, this is what the Hurricane of 1938 did to the Immaculate Conception Church steeple behind those businesses. A steeplejack is above the clock. Both Delaney's and Masciarelli Jewelry, shown here, have been located at various spots along Main Street throughout the years. (Courtesy of James and Jean Durand.)

THE ICE STORM OF NOVEMBER 1920. For several days during the ice storm of November 1920, misting rains froze up to a thickness of two inches. Many utility poles fell from falling tree branches and the extra weight added to wires. In some places, the lack of poles prevented any telephone or electric service until the following spring. Instead, kerosene and gasoline lamps had to be used. Another storm was on July 2, 1888, when three inches of hailstones as large as walnuts fell and killed many crops and birds.

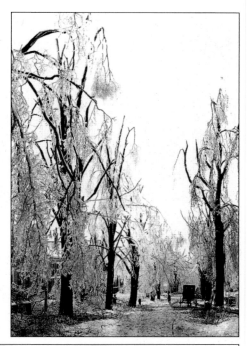

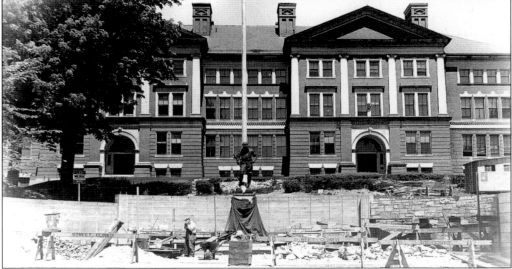

THE WORKS PROGRESS ADMINISTRATION. During the Great Depression, Pres. Franklin Delano Roosevelt was in office. Congress instituted the Works Progress Administration (WPA), which administered many different kinds of projects to sustain the vast unemployed population with some work and income. Throughout the nation, many bridges, reservoirs, roads, murals, musical recordings, oral histories, and literary works resulted from this innovative effort to maintain economic activity during financially challenging times. This particular WPA project is still used frequently. The already existing doughboy statue had been situated farther back, closer to the building, but the new work during the Depression created a half-shell setting with benches closer to Main Street. By this time, the old high school (later the Walker Building) had its new half on the left-hand side.

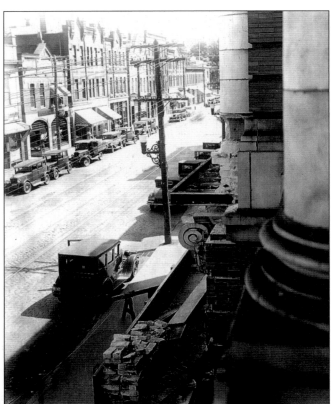

THE CITY HALL FACELIFT. Taken from a high point on the front facade of city hall, this photograph offers a point of view from above, looking down at Main Street in the 1920s. Dedicated on July 16, 1906, the new city hall was built by T.P. Hurley. The architects were Allen, Collins, and Berry. F.R.S. Mildon, C.W. Curtis, T.F. Carey, Rufus Clark, C.F. McCarthy, J.D. Donahue, S.P. Wood, B.W. Johnson, Moise Sasseville Jr., J.A. O'Connell, M. Burke, Charles Favreau, J.P. Brown, W.D. Lepper, and Charles Holyoke were on the city hall building commission.

CITY HALL WORKERS. Standing on the city hall steps c. 1937 are, from left to right, Beatrice Grenier; Mae Lafleur, clerk; Ruth Dacey, clerk in assessor's office; Harold Brigham, water inspector and sewage commissioner; Barbara Scott; Regeame Lacroix, clerk; Alma Cowern, street clerk; Mary Hogan; Ernest L. Faunce, auditor; and Tim J. Harris, city almoner.

CITY HALL EMPLOYEES AND ELECTED OFFICIALS. Enjoying their annual outing at Lake Quinsigamond Park in Worcester in the late 1920s, from left to right, are the following: (front row) Tom Coyne, Fire Chief Henry Brown, Tim Harris, Mayor Winfield Temple, Eddie Simoneau, Charlie McNally, Dick Denoncourt, Ernest Faunce, and Louis Putnam; (middle row) Leonidas Martel, Cliff Sowerby, Bob Jameson, Jim Carey, Leo Maybay, Sam Daoust, Jack Chamberlain, Gene Lawrence, Hector Moineau, and Charles A. "Harry" Cook; (back row) Danny Connors, Fred Angier, George White, Elwyn Spinney, Harrison Brigham, Joe Gallagher, Fred Williams, Harold Brigham, Stillman Stevens, and William Osgood.

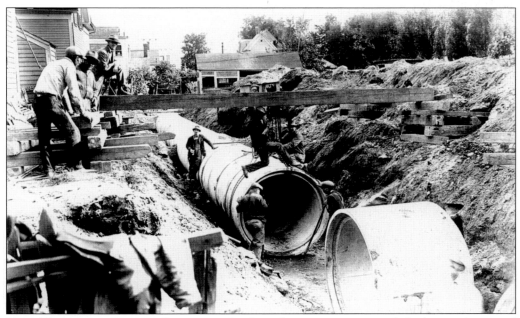

THE HARDIMAN BROOK CONDUIT. A glass-plate negative recorded this underground infrastructure by Dow Place in a view looking southeast toward upper Maple Street near Bridge Street. Leo Maybay, a WPA employee, is second from the left, next to Tom Coyne, who has one foot on the beam. On top of the pipe on the right is Jerry McCarthy.

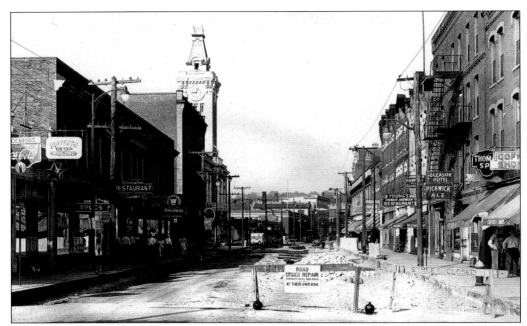

STREET REPAIR. By the sawhorses in front are small black balls used for safety at night. They were lit in order to alert motorists and pedestrians of hazardous construction. Neon signs are plentiful on both sides of Main Street in 1947. The city hall clock—donated by the first vice president of Marlborough Savings Bank, Winslow Warren, now retired—says it is 9:05 a.m.

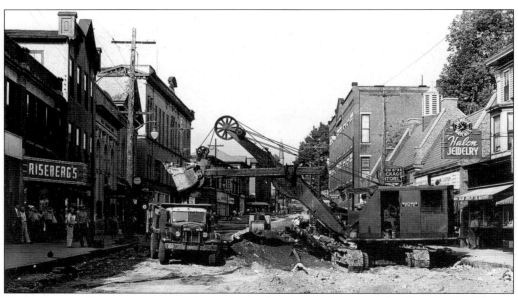

MAIN STREET RECONSTRUCTION. In a view looking west, the top of the First Baptist Church is seen behind the truck's lines. In the background on the left is the Masonic Building, formerly called the Fairmount Hall Block. It is next to the First National Bank, and in the background on the right is the Oddfellows Building. Riseberg's was located at 194 Main Street and offered both men's and ladies' clothing, as well as furnishings. It was established in 1910.

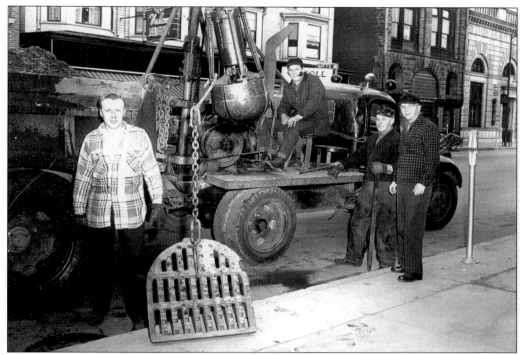

CLEANING CATCH BASINS. Cleaning catch basins, an important task for the prevention of street flooding, is taken care of by (from left to right) William Carroll, Steve Agoritsas (on the truck smoking a pipe), Ted Gallagher, and Eddie Kelley. On the other side of Main Street is the Peoples National Bank.

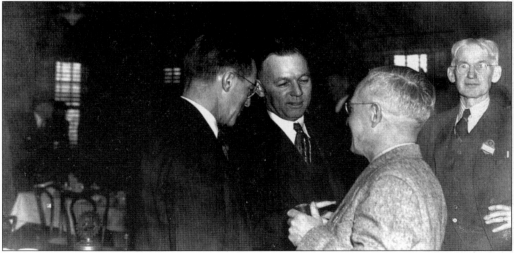

NETWORKING AT THE ROTARY CLUB. Movers and shakers at the Wildwood Inn in the 1950s include, from left to right, architect and Marlborough Chamber of Commerce secretary John A. Bigelow; Governor Bridges of New Hampshire, print shop owner and Marlborough Chamber of Commerce president J. Vincent Lyons, and furniture dealer J.J. Bradley. This inn is now the Wildwood Restaurant at 189 Boston Post Road (Route 20). The current owner's father purchased it from proprietor Thomas F. Kileen.

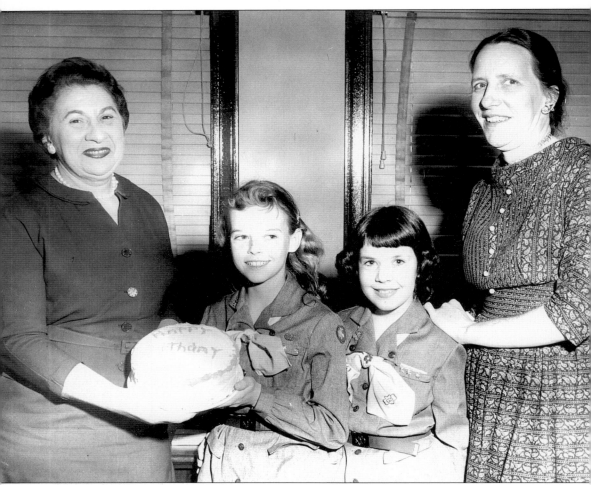

LIBRARIANS AND GIRL SCOUTS. Librarians Bertha L. Shapiro (left) and Eleanor Jones celebrate Girl Scouts' birthday with Jackie Curtis (on left, the future wife of John Dana Hanley) and Susan Zilembo *c.* 1960. Shapiro served the public library from 1952 to 1976, passing away recently at the age of 96. Her sister Mary Shapiro also worked for years at the library, as did the beloved Eleanor Jones, who is credited with starting the children's area in the basement in May 1953, thanks to funding from William Burdett. The library's sculpture garden depicting the fabled race in "The Tortoise and the Hare" was designed by the Panagores in memory of Jones, who died in April 1996. Its four bronze figures are by sculptor David Kapetanopoulos, who grew up in Marlborough and also sculpted *The Shoeworkers* in Centennial Park at the corner of Granger Boulevard and Route 85 adjacent to the Rockport Company. (Courtesy of Marlborough Public Library.)

Four

SHOE TOWN

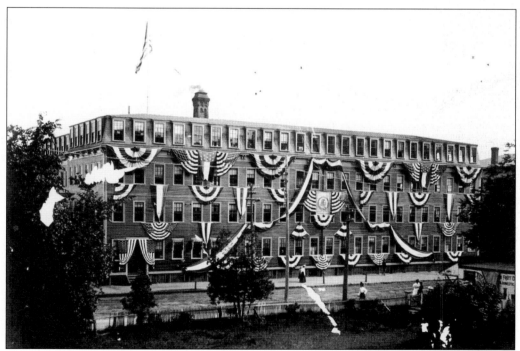

THE BIG SHOP DECORATED. For the city's 250th anniversary celebration in 1910, this vast factory building provided a lot of backdrop for patriotic bunting and ribbons. In its center is a banner showing a longhaired man's profile. Samuel Boyd began shoemaking in 1836, in a small place where Ted's Lawnmower on Maple Street is today, using an awl, knife, and hammer, but he believed that, through division of labor, the process could be faster and more efficient. This was one of his shoe factories.

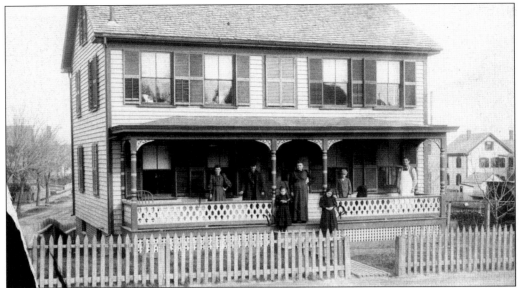

BUCKEYE SHOP. At the southeast corner of Chestnut and Broad Streets, a two-story home was built using chestnut beams before the late 1880s. Located at 135 Broad Street, it included a shoemaker's workshop and has remained in the family for three generations. From left to right are Anna (Beaudry) Bourgeois; her husband, Edmond Bourgeois; Anna's niece Donalda (Sasseville) Phaneuf; Anna's mother, Margaret; Anna's niece Blanche (Sasseville) Durand; Anna's brother Hormidas "Jack" Beaudry; and Anna's father, Jean-Baptiste "Joseph" Beaudry, whose store also sold meat and homemade liquor. Jean-Baptiste was the first person buried in St. Mary's Cemetery. Edmond Bourgeois's brother was Moise, and he worked in the store, as well as Roland Dessein, Isiah Boule, Gaston Bourgeois, Vincent Werner, and Ernest Bourgeois. From working for François X. L'Heureux, Edmond learned meat cutting, and then opened his own grocery store at 528 Lincoln Street.

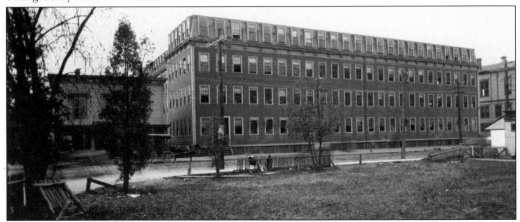

SAMUEL BOYD AND THOMAS COREY'S MAIN STREET FACTORY. This picture was taken from the corner of Bolton (Route 85) and Main Streets. Upon the grass yard in the foreground, the old fire and police station was built. The enormous five-story shoe factory, owned by Samuel Boyd and Thomas Corey, occupied one and one-half acres. In August 1872, a Japanese delegation toured this factory, one of the largest in the country, and then enjoyed a reception at the town hall. (Courtesy of Marlborough Public Library.)

BOYD AND COREY'S BLOCK. Shoe barons erected entire downtown blocks. From this Main Street building, stoves, hats, and printing services were sold as early as 1869. The telephone company, in its infancy, was located upstairs. Partners Samuel Boyd and Thomas Corey also built many homes. In conjunction with John O'Connell, Boyd developed modest houses for factory workers in the Howe Street area. Near his own estate, Corey created smaller lots around Church Street. Later, Boyd purchased much of Maj. Henry Rice's family farmland, north of Main Street between the East and West Villages, and developed Devens Street.

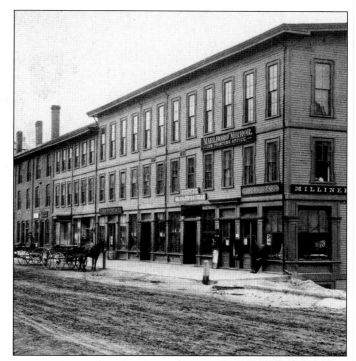

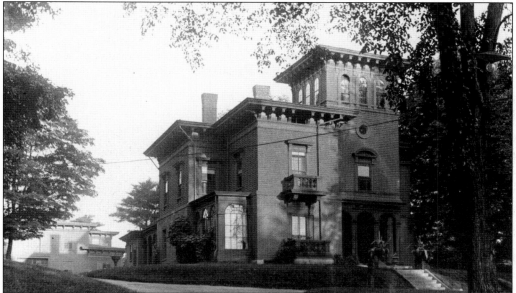

THE BOYD MANSION. On top of Fairmount Hill, shoe manufacturer Samuel Boyd built a comfortable home of his own, decorated with Italian marble; parquet floors; a circular mahogany staircase lined with 6-foot-high niches for statues; tiled fireplaces; gold-leafed walls, 12-foot ceilings; walk-in closets; frosted, flowered, and stained glass doors; a two-story barn; a billiard room; tar walks; and various fruit trees. Here, he hosted fancy balls. He kept the nearby Adams Street area free from houses until the 1870s. Boyd generously kept most of the hill as a park for picnics and even erected a dance pavilion in 1907.

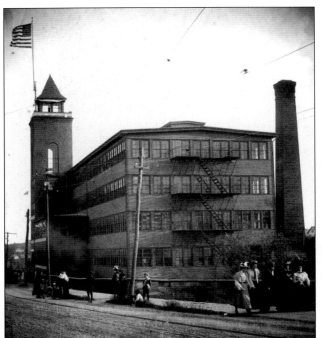

A FACTORY ON MAPLE STREET. Originally the Commonwealth Shoe factory, this building was called the Germania when it manufactured electric light bulbs. It housed the Ashby-Crawford Company, which made Trot-Moc Shoes. Cooper, Liberty, and Thompson was also here, as well as the Marlboro Shoe Company and Mutual Shoe. Tanneries supplied the processed leather for footwear.

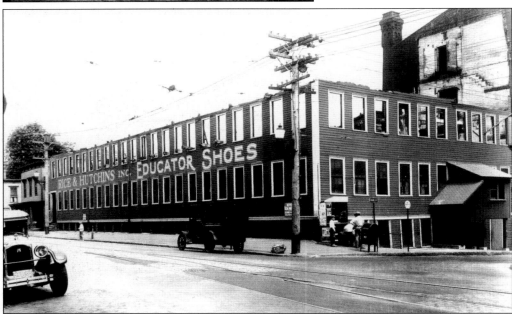

RICE AND HUTCHINS SHOE FACTORY. In 1871, Samuel Boyd built the Rice and Hutchins Shoe factory. Electric power for the Marlborough Street Railway was generated from within, beginning in 1889. It was the second electric street railway in the nation. Boyd financed the railway himself, since he realized the importance of transportation for factory workers around the city. Here, the Mystic Building Wrecking Company of Chelsea has already begun demolition; the top floors have been removed. This view is at the corner of Howe Street, which once reached Main Street.

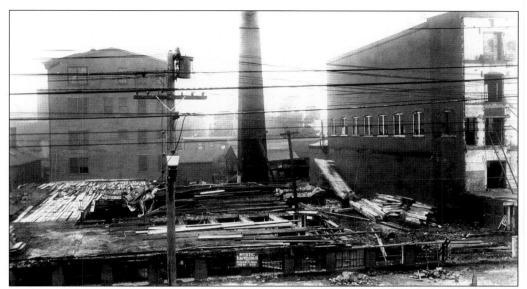

THE BIG SHOP IS GONE. The chimney of the Rice and Hutchins Shoe factory remains and is recognizable by its distinctive shape and tall size, as seen here. The partnership of William B. Rice of Marlborough and Horatio H. Hutchins, a Hudson clothier, began in 1866. In 1875, Rice and Hutchins made men's medium-priced balmorals and congress boots, as well as women's polished boots. With several factories, it was Marlborough's largest shoe company for a while.

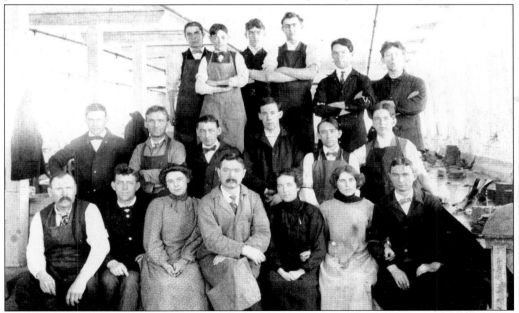

A CUTTING CREW. On the bench on the right, some shoes are being made. Leather has been sewn around wooden lasts (foot forms). Large windows and white walls maximize the light necessary for precision cutting. Standing in the very back of the cutting crew, third from the left, is future judge James M. Hurley, and fourth from the left is his brother Dennis. Immigrants eager for work flowed in from Canada, Italy, and Ireland to work 16–18 hours a day, and some were as young as 12. (Courtesy of Paul H. Hayes.)

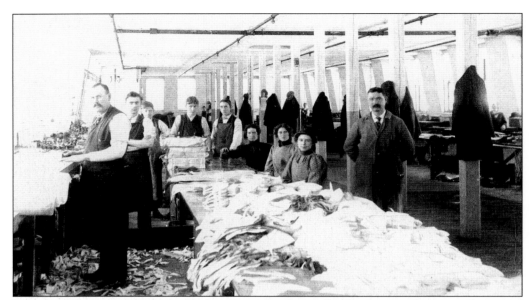

THE CUTTING ROOM. Patterns for shoes were sliced out of leather in ways that created minimal waste, but scrap leather businesses sprung up around town anyway. Frank Billings began his in 1881. The inventions of the sewing machine and steam engine further aided the shoe industry's growth, as well as improvements in transportation and an increased demand for soldiers' boots. Second from the left is Dennis Hurley, and fourth from the left is James Hurley, both uncles of Paul Hayes. Even though young James dropped out of high school, he eventually became a successful school administrator. (Courtesy of Paul H. Hayes.)

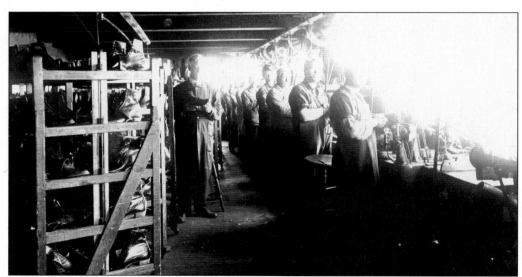

OTHER STEPS. On another floor of the shoe factory, a different stage of the shoemaking process takes place. Each floor had dozens of shoe racks, like the one on the left, to hold pairs of shoes that were being worked on. These racks had wheels and were noisy when pushed across the wooden floors. Whistles blew for lunchtime and quitting times. The names of other jobs were lacers, stampers, cementers, and fancy stitchers.

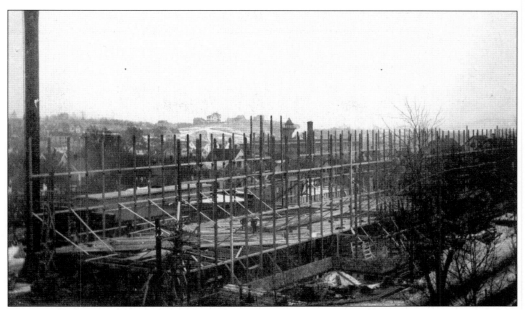

THE CURTIS FACTORY ON HOWE STREET. Under construction in 1901 is the Curtis Shoe factory on Howe Street. The tower of the shoe factory on Maple Street can be seen behind the white plume of steam in the center. In the distance is a bare Chestnut Hill. Factories, farms, mansions, shops, churches, and schools were fairly evenly spread out across Marlborough's land, unlike most other early New England towns, which seem to have more delineated sections of town. (Courtesy of Marlborough Public Library.)

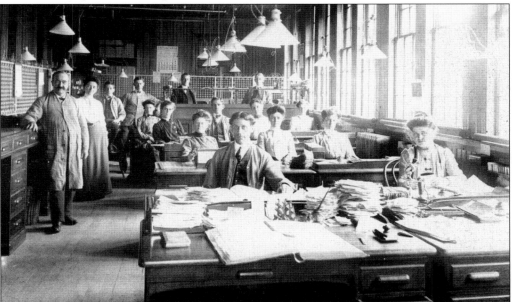

THE SHOE FACTORY OFFICE. Inside the Curtis Shoe factory, 16 office workers keep up with accounts receivable, payroll, and inventory. In 1909, Marlborough turned out about 6,150,000 pairs of shoes, a conservative value of $10 million. Commercial Photo Company on Broadway Extension in Boston printed this picture taken on May 4, 1903. (Courtesy of Paul H. Hayes.)

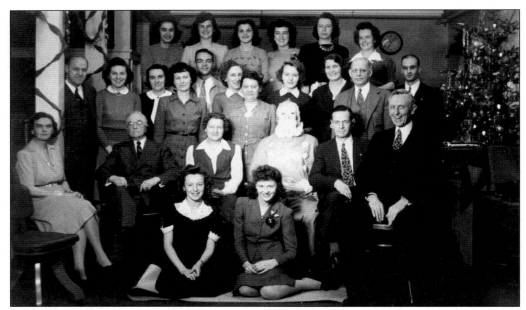

A Christmas Party with Santa. The office Christmas party at Curtis Shoe in the 1940s included Al "Santa" Hastings, as well as his sister Cynthia Hastings, John A. Curtis, John A. Curtis Jr., Mercer E. Curtis, Charles W. Curtis, Arnold S. Curtis, Rita Argalli, Ethel Beals, Margaret Hoffman, Shirley Kinder, F.W. Pratt, Rita L. Collette, Rita Riccuti, Abbie Powers, F.N. Barlow, Viola M. Pierce, Elsie Davis, Ruth Gale, Doris Park, Frannie LaBrache, Mary Sheldon, Lois Sherman, and Dottie Pontes. One person remains unidentified. Helen Clarke worked here and may have snapped this photograph. A manual typewriter sits under the tree.

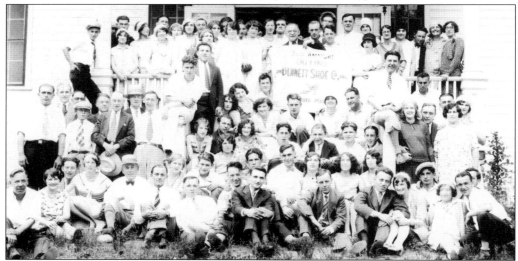

Bennett Shoe Company. It is the second annual outing for employees of Bennett Shoe Company, located at 55 Howland Street, in the 1930s. Myer Ornsteen is the president. Amongst the group are Ruth Orcutt, Flora Gour of 60 Broad Street, Lillian P. Marcheterre of 15 Broad Street, and George F. Parizeau of 162 Winter Street. A few years earlier, the board of trade adopted a new name, the chamber of commerce, along with a new mission of advocating civic and community interests.

60

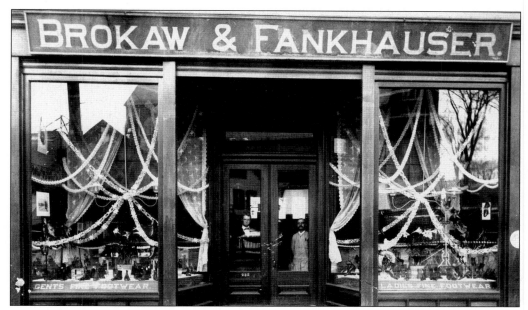

EASTER SHOES. This shoe store is decorated for Easter in 1899. It was located at 232 Main Street on the Phoenix Block.

PARTY AT THE PRESTON. A complimentary banquet was held on Monday, October 2, 1893, at the Preston, a hotel John A. Frye owned on Lincoln Street. Included on the menu were oyster patties á la reine, sweetbread croquettes á la union, banana fritters, roast red head duck, mock turtle, filet of salmon au petit pois, filet of beef aux champignons, sweet potatoes, larded grouse, and lobster mayonnaise. F.B. Estabrook was the printer of this fine invitation, which is tied with a pink ribbon.

WALTER P. FRYE AND FAMILY. The children and their families gathered to celebrate the the Fryes' 50th wedding anniversary on March 31, 1935. From left to right are the following Frye family members: (front row) Jean, Walter, Addie, Natalie (Russell's daughter), and Eleanor Bonsall (Russell's wife); (back row) Preston, Charlotte, John, Russell, Robert Jr., Edna L., and Robert P. Neither Charlotte nor John had children.

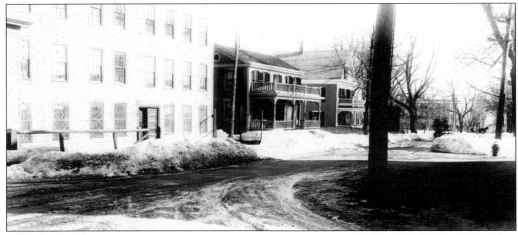

FRYE BOOTS REDISCOVERED. A resurgence of desirability for this particular make of quality leather boots occurred in the 1970s, thereby making Frye boots a familiar brand name in more contemporary times, as well. On the left is the factory, founded in the late 1800s by John A. Frye at the corner of Chestnut and Pleasant Streets, in a view looking south towards Lincoln Street. Before beginning his own company, Frye worked with S. Herbert Howe, Marlborough's first mayor, in his shoe shop. In 1889, Frye was the first shoe plant here to use electric power, another key to the city's shoe success. In this photograph dated Friday, March 5, 1926, two horse-drawn sleighs are blurring by on the right.

Five
"I Love a Parade"

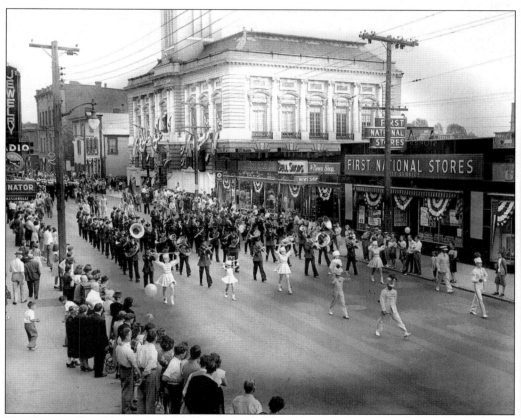

THE LABOR DAY PARADE 1946. Baton twirlers, bands, and spectators all joyfully celebrated the return of the young soldiers who had gone overseas to fight in World War II. The September tradition of a big parade continues, making Marlborough one of the few communities to still host a Labor Day parade.

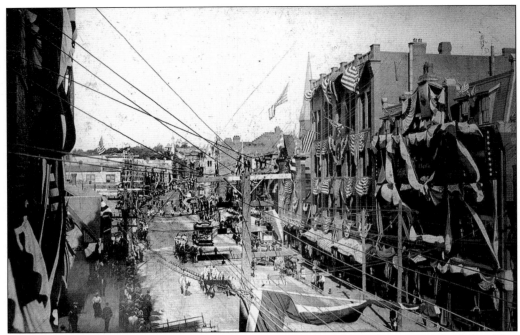

THE FOURTH OF JULY. In 1900, the city held a parade to celebrate the nation's birthday. This picture, a view looking up Main Street toward Monument Square, was taken somewhere from the old city hall. (Courtesy of Marlborough Public Library.)

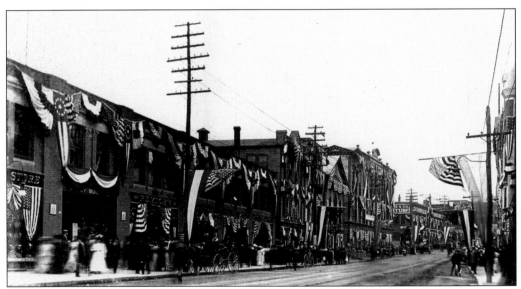

MAIN STREET PARADE. During Marlborough's 250th anniversary celebration, the businesses decorated with red, white, and blue flags, ribbons, and bunting. Women's dresses almost touch Maine Street. John "Honey Fitz" Fitzgerald, John F. Kennedy's grandfather, attended one of the parades. The large entranceway on the left before Remick's is for the Corey Building. On either side, about one-third of the way up the street, are small placards with the familiar New England Telephone bell logo.

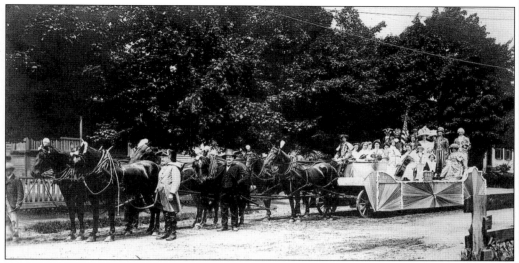

MARLBOROUGH'S HISTORY VIGNETTE. Figures spanning the community's 250-year history are portrayed in costume upon this 1910 parade float. The photograph's donor, Antoinette Testa, stated that these city barn horses were stabled on Fairmount Street. Shoe industry leader Samuel Boyd also kept his fine horses on Fairmount Hill.

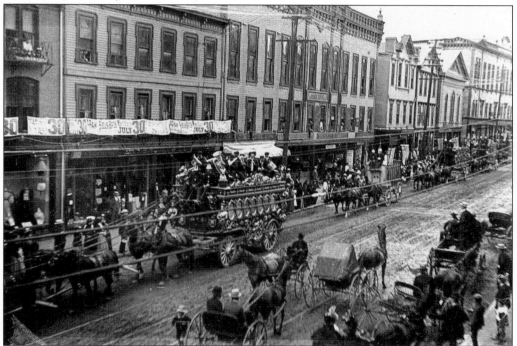

THE SELLS BROTHERS CIRCUS. When the circus came to town in the old days, there was a procession from the train station to the circus grounds. Animals, tents, apparatus, calliopes, and costumes were hauled by elephants, mules, and horse-drawn wagons. The Sells Brothers Circus traveled a great distance. Banners alongside Main Street businesses are promoting a July 30th show. Taken near Florence Street, this scene is just slightly up from the Main Street parade photograph on page 64.

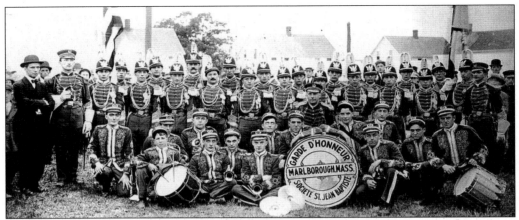

GARDE D'HONNEUR. Fourteen local musicians are in front. This photograph is from the early 1900s, when the French-Canadian population was so great that French Hill became the name of the neighborhood around Lincoln and Broad Streets, where this semi-military group, Garde d'honneur, assembled.

ON CITY HALL'S STEPS. Reviewing the 1955 parade from the steps of city hall are the following: (front row, seated) Sen. Charles Olson from Ashland, city councilor Nicholas DiBuono Sr., Michael Manning, Charles Lyons (with a cane), Gov. Endicott Peabody, and Mayor Romeo Gadbois; (back row, standing) Edward Cusson, James Carr, George Hutch, and attorney Genaro Morte. Seated and barely visible on the left, in between councilor DiBuono and Manning, is Charles Kelleher.

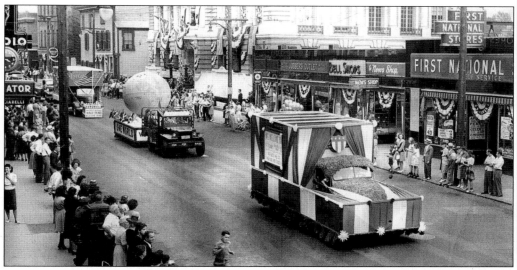

WELCOME HOME WORLD WAR II VETERANS. On September 2, 1946, the Labor Day parade had a strong theme to honor the returning soldiers: "A Home Town Welcome." In front of the First National store is the Koehler Manufacturing Company float. Following Koehler's is a globe on the Curtis Shoe factory's float. It says "one world." "Wave for peace" is the message on the Frye-Corbin Shoe Manufacturing float in front of a decorated city hall.

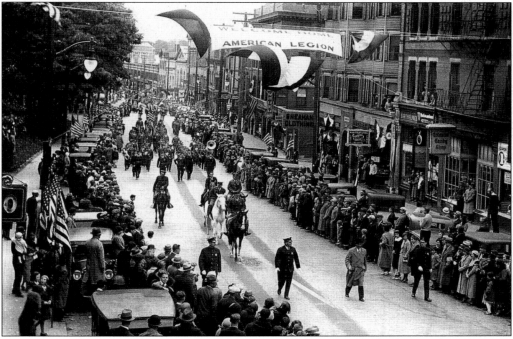

THREE-TIME NATIONAL CHAMPIONS. As mayor, Charles Lyons leads the parade welcoming home the American Legion Drum and Bugle Corps from winning the 1932–1933 national championship. Seen here on foot and wearing a light colored coat, the "Depression Mayor" never married. A full-page photograph showing this drum and bugle corps with the "right combination of skill, precision and rhythm" was used to advertise Chesterfield cigarettes in 1939.

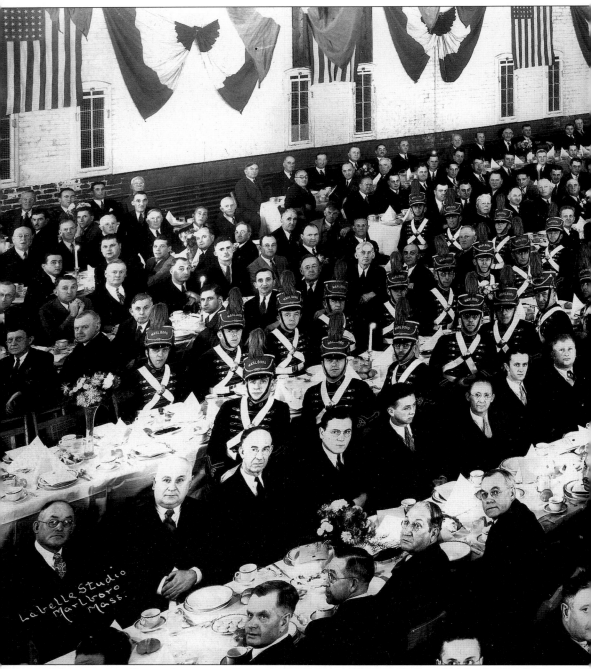

Labelle Studio
Marlboro
Mass.

COMMUNITY FETES AMERICAN LEGION DRUM AND BUGLE CORPS. Inside the brick State Armory on Lincoln Street, an almost all-male gathering pays homage to the national champions from Marlborough in this panoramic photograph. It was almost Halloween in 1934

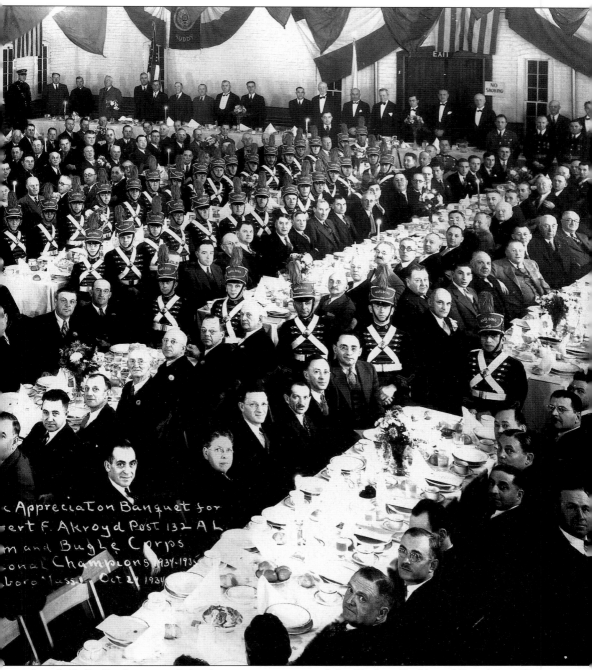

Appreciation Banquet for
ert F. Akroyd Post 132 A.L.
m and Bugle Corps
onal Champions 1934-1935
boro' Mass. Oct 27 1934

when LaBelle Studio created this large group picture of the Herbert F. Akroyd Post No. 132 American Legion Drum and Bugle Corps and supporters at an honorary banquet. Once again, they had made the city proud and won the national championship.

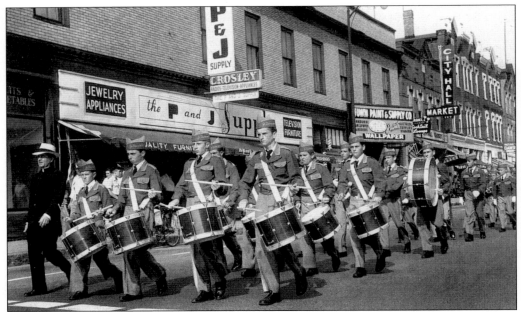

THE DUKES. The Immaculate Conception Senior Drum and Bugle Corps captured the State Catholic Youth Organization championship. The traditional Labor Day parade marched down Main Street near city hall in the fall of 1955. Due to their popularity and success, drum and bugle corps teams thrived in Marlborough.

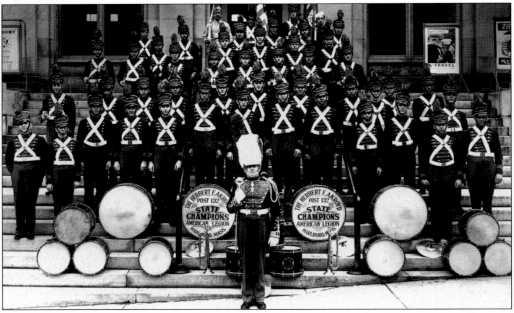

SEVEN-TIME STATE CHAMPIONS. The American Legion Drum and Bugle Corps proudly poses on the steps of the old post office on Mechanic Street c. 1947. Included in the team are Charles Ripley, Ed Logan, John Coughlin, Bill Quercia, Bill Fitzgerald, John Brown, Carl Ellery, John Fanning, Myron Lynch, Dave Zanca, and Ivan Dunne. The drum major was Harry Sherman. (Courtesy of Dick LaFreniere.)

HIGH SCHOOL MAJORETTES. In 1955, the annual Labor Day parade marched down Main Street through Monument Square by the Marlboro Theater and the G.A.R. Building, which still displayed the John Brown Bell.

THE HIGH SCHOOL BAND. Marlborough's teenage marchers assemble in front of the old high school c. 1950. In the front, from left to right, the young women are Berniece Staplefield, Jill Coughlin, Pauline Woodworth, Sue Kane, Marilyn Whittemore, and Pat Ercolani. Also included in the picture are Henry Riano, Ray Mancinelli, Bob LaBrecque, Louise Mulhall, Randy Rando, Patty Temple, Doris Colena, and Bob Cipriano. (Courtesy of Dick LaFreniere.)

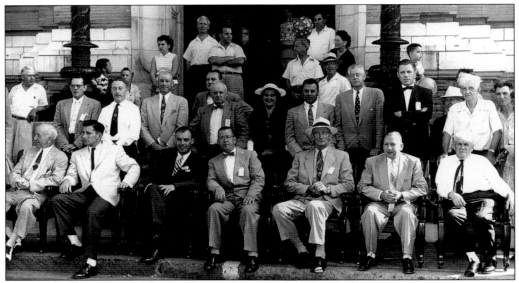

THE LABOR DAY PARADE REVIEW STAND. At city hall's entrance the Labor Day parade is watched by the following, from left to right: (front row, seated) Charles Lyons (former mayor), George Hutch, Lt. Gov. Sumner Whittier, Romeo Gadbois (mayor), Senator Olsen of Ashland, Nicholas DiBuono Sr. (councilor), and Michael Manning; (back row) James W. Forrest (Ward Two councilor), John Bradshaw (insurance agent), Waren Maddox (Marlborough High School teacher and sealer of weight and measures), Francis Kane (building contractor), Ruth Dacey (school committee member), Genero Morte (attorney), Bert Bergman (shoe vendor), William F. Brewin Sr. (attorney), and Frank Dupuis (a printer at Dennison Manufacturing). Mayor Gadbois was also employed as a printer in Dennison's Marlborough plant.

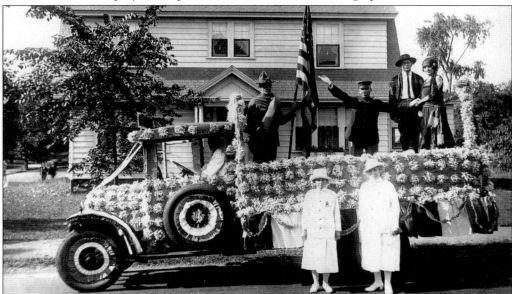

SPANISH-AMERICAN WAR FLOAT. Delphinne Fritcher, Lillian Barret, Aaron Hosmer, and John S. DeYoung helped design a parade entry depicting the brief conflict with Spain. Behind the motorized vehicle is the Moineau family home on Mount Pleasant Street.

Six
ASSOCIATIONS
AND CELEBRATIONS

THE ORDER OF UNITED AMERICAN MECHANICS. A concert was presented by the Golden Rule Council, No. 23, of the Order of United American Mechanics at the old town hall on March 3, 1886. Professional singers were met at the train depot. The stage was set up in front of the hall's long benches by George S. Parker, committee chairman, with assistance from L.L. Tarbell.

TROIS AMIS. Arthur St. Pierre, George Marsan, and Leon Fontaine are three friends affiliated with the French associations. To name a few of the many organizations based upon French Hill, there were Union Dramatique, the French Canadian Band, the French Republican Club, and the French Naturalization Club. Two of the young men are wearing tags on their clothes, so perhaps they are on some type of outing to a park.

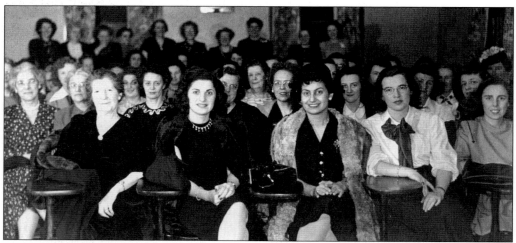

THE MARLBOROUGH NURSES CLUB. In 1948, officers for the Graduate Nurses' Club, pictured here from left to right, were Alice K. Bryant, president; Victoria Fay, vice president; Margaret Moitozo, secretary; and Edith Huntington, treasurer. The club, organized on March 12, 1933, held a charity ball at the State Armory featuring Ruby Newman's Orchestra. Like the Tudor Club, the nurses' club helped the needy and provided social support for its ambitious members. The Graduate Nurses' Club still existed in the 1960s.

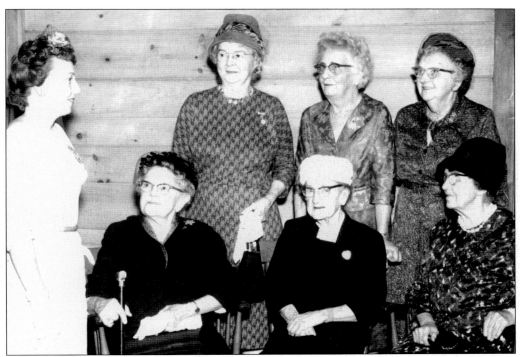

THE NEWMAN CLUB. Members of this social and literary club include the following, from left to right: (seated) high school teacher Grace K. Dalton and two unidentified members; (standing) Elsie Brigham Dineen, unidentified, high school teacher Mary "Minnie" Coyne, and shoe worker Marguerite Fee. This organization was formed in 1897.

FOURTH OF JULY, TOWN HALL. Inside the old town hall, in 1873, an Independence Day celebration is planned. On the back of this stereo view, the photographer printed "opposite town hall" under his name.

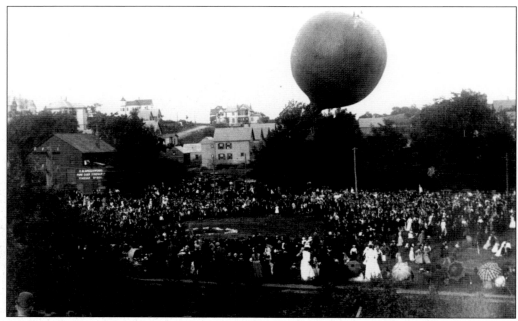

A HOT AIR BALLOON. This Fourth of July celebration is in 1890 by Marlborough Junction, one of three railroad stations in the city. Greenwood's Cider Mill is on the left.

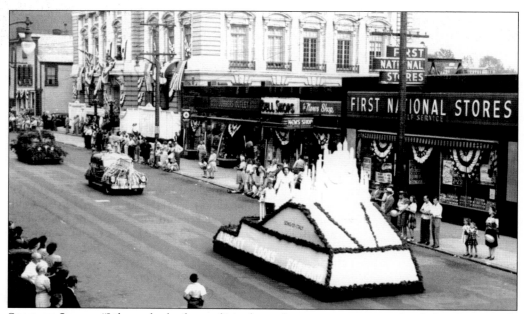

SONS OF ITALY. "Liberty looks forward" is the welcoming message on this Labor Day parade float. Another ethnic group attracted by the thriving shoe industry was the Italian population, which established itself in the early 1900s. St. Ann's, on the corner of Lincoln and Gibbons Streets, is the Roman Catholic Italian church, which began in 1921. Many Italians lived around "the swamp" in the South Street area and grew grapes and vegetables. On Francisco Valianti's land was an earlier church.

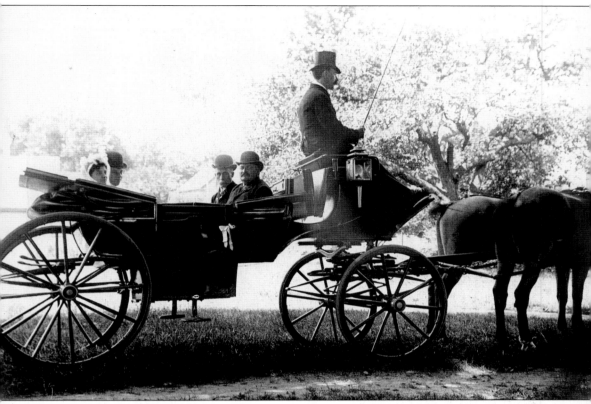

THE HUBERT WEDDING. On this occasion, the baker's daughter, Eva LaCroix, becomes Mrs. Hubert. Both fathers sit opposite the young couple. The larger man is the bride's father, Alberic LaCroix, who sold bread, cakes, and pastries at 131 Broad Street.

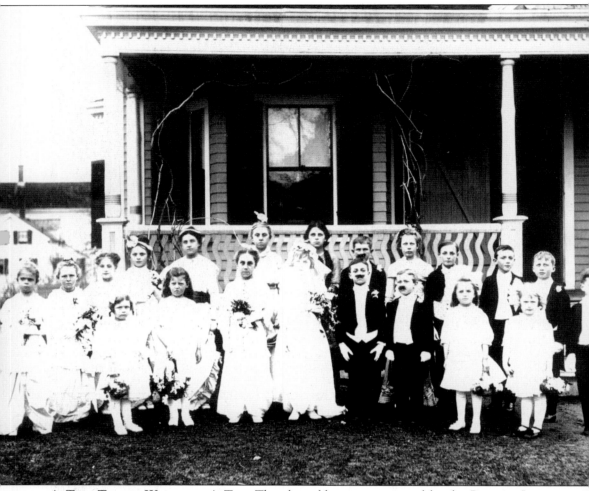

A TOM THUMB WEDDING. A Tom Thumb wedding was organized by the Patriotic League during World War I in the Shawmut Avenue neighborhood. The first girl in the front row on the left is Gwendolyn Ernestine Brown. Second from the right and not wearing a moustache is Frank Brown. Dorothy and Arlene Herrick, "bride" and "maid of honor," are in the center. They lived at 33 Greenwood Street. The Patriotic League worked hard to keep up the morale of Marlborough soldiers and their families. Evidently, these "wedding" parties evolved from the long-lasting media attention paid to the real-life midget who became a celebrity via showman P.T. Barnum. Internationally renowned, Tom Thumb even met Isabella of Spain.

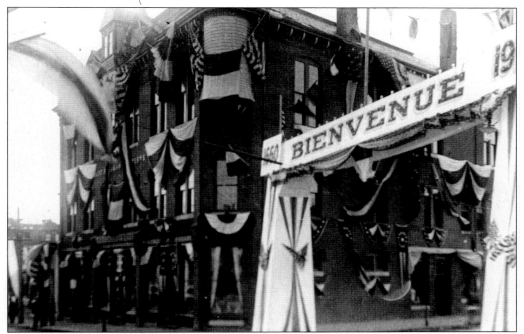

A FRENCH WELCOME. A 30-foot arch was erected by the St. Jean Baptiste Society on Broad Street. The opening was 25 feet wide for the 1910 celebration. The letters were illuminated, and "Bienvenue" was lit with 600 to 700 lights on the arch. It was decorated with American and French flags.

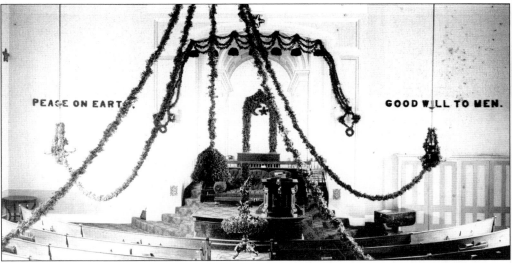

CHRISTMAS DECORATION. Inside the Universalist church on Main Street, simple greens denote the season. On the rear wall are letters forming the words for celebration. The church's earlier building was located at the corner of Ames Place and Main Street in 1829 and was destroyed by fire in 1845. This replacement structure was built with two stores underneath: Hanley's and Blake's. In 1975, fire destroyed this building, which had been purchased by Nathan Riseberg in 1958 and remodeled for his clothing store. Riseberg's Department Store was erected in its place between the Masonic Building and the former First National Bank.

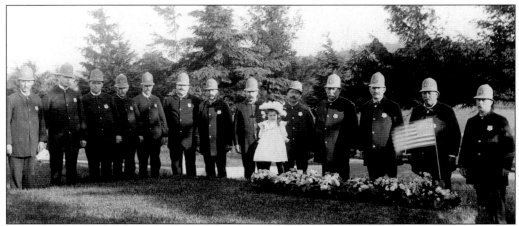

A SOMBER OCCASION. Thirteen men in blue marched two by two from the police station house to the Catholic cemetery carrying bouquets, which they placed upon the grave of their departed comrade John T. McCarthy. Helen (McCarthy) Bill is the little girl who also laid flowers on her father's grave *c.* 1909. The regular officers are Sgt. Cornelius Flynn, Placide Durand, J.F. Connors, J.L. Callahan, P.H. Loftus, T.A. Driscoll, G.D. Brigham, J.E. Kennedy, George L. Herrick, and J.J. Buckley. The reserve officers are B.T. Mitchell, Terence O'Brien, and Hugh McNiff.

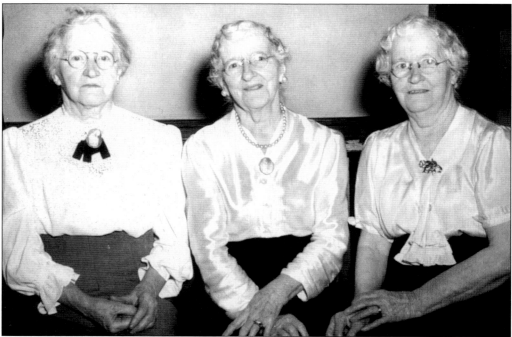

FAITH, HOPE, AND CHARITY. The country's oldest set of triplets celebrated another birthday on March 27, 1959, when they turned 91. Although they resided on Witherbee Street for years, the Coughlin triplets originally came from North Brookfield, where they were friends and neighbors of actor-playwright George M. Cohan. They were born in 1868 and featured in *The Guinness Book of World Records.* Annie Faith (Coughlin) MacDonnell had a son George who lived in Marlborough.

Seven
SCHOOL AND RELIGION

THE CLASS OF 1884. When the burden of running Marlborough's many schools without an administrator became too much for the school committee alone, the first superintendent of schools was hired in 1884, the same year this class graduated. The graduates from left to right are James Foley, William G. Burdette, Lucy Baker, Mabel Holt, and Carrie Winch. (Courtesy of Marlborough Public Library.)

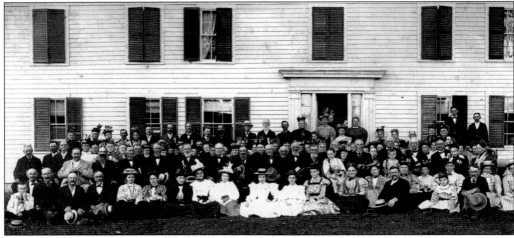

A SCHOOL REUNION AT GOODALE FARM. Warren School reunions were held here in the early 1900s. Six generations of the Goodale family grew up on this expansive farm, also called the Time Stone Farm. Dea. Abner Goodale served on the school committee in 1803. Lucy Goodale married Asa Thurston of Fitchburg, before quickly departing for the Sandwich Islands in 1819. They were well-known missionaries who were included in John Michener's bestseller *Hawaii* and bore the first white child there. Dea. David B. Goodale presented a cabinet of 250 mineral specimens to the high school in 1876. He also corresponded with Rev. Horatio Alger, father of the famous author, on church matters. In the Spring Hill Cemetery is the raised Goodale family plot.

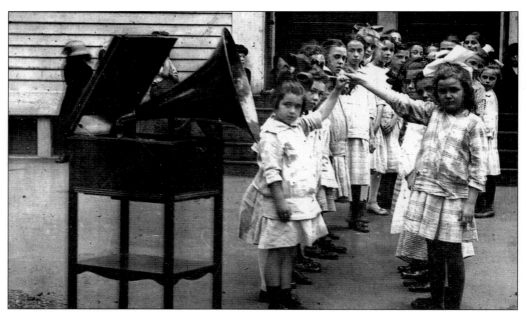

MUSIC EDUCATION. Pleasant Street School students employ a wind-up gramophone to hear music in the schoolyard. At the corner of Elm and Pleasant Streets was this older school building, prior to the construction of the John J. Mitchell School, which was later sold to the Boys Club. When music was introduced to the curriculum in 1874, the schools gave a musical festival at the town hall.

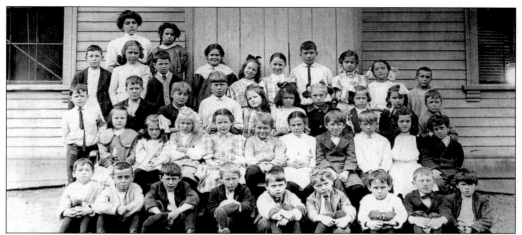

THIRD AND FOURTH GRADERS. Students of the Essex Street School *c.* 1908 were, from left to right, as follows: (first row) John Werner, William Cameron, Earl Parker, Herbert Washburn, ? Fernald, Bernard Loftus, David White, Lyman Washburn, and Vincent Cahill; (second row) Evelyn Wakefield, Katherine Sullivan, Myra Seus, Marion Joyce, Ernest Colman, Helen O'Donnell, ? Lynch, Charles Gibson, Helen Fitzgerald, and Irving Parker; (third row) Francis Crotty, Charles Harris, George Lynch, Philip Gibson, Helen Cahill, Mary Kelly, Dorothy Herrick, Mary Downey, Mary Grogan, and unidentified; (fourth row) Ed Perritt, Mary Loftus, ? Curley, Pauline Stumpf, Marion Haukard, Isabelle Schwartz, Henry Lacombe, ? James, Aura Lacombe, and Robert Cameron. Evelyn Hall is the teacher in the back with an unidentified girl.

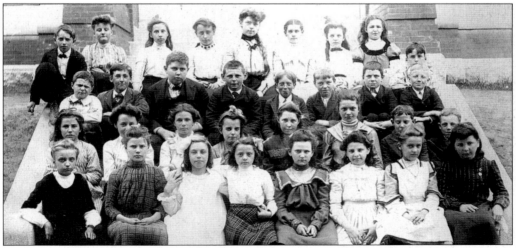

SIXTH GRADERS C. 1903. The Centre School was located on Main Street before it was torn down to make room for the addition to the old high school (today's Walker Building). These *c.* 1903 sixth graders, from left to right, include the following: (first row) Mabel Leighton, Winona Taylor, Stella Beaudry, Dorothy Elderkin, Nellie Kelleher, Helen O'Connell, Helen Gordon, and Madeline O'Connell; (second row) Mary Dalton, Alice Ripley, Ann Riley, three unidentified children, Charles Peckham, and Lyman Evans; (third row) unidentified, Ulysses Brigham, Russell Belser, Charles Shanahan, Ernest Daley, ? Hanley, ? Coughlin, and unidentified; (fourth row) Moon Cain, unidentified, Berenice Gedes, Nellie Works, Bernice Adams, unidentified, Mary Lynch, and Harriett Kelley.

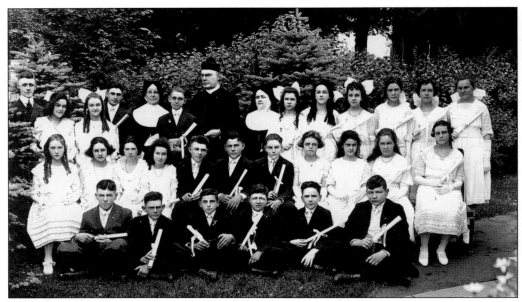

IMMACULATE CONCEPTION SCHOOL. It is graduation day for the eighth grade class at the Immaculate Conception School, a private Catholic school located very near the Immaculate Conception Church on Prospect Street. The parochial school began in the early 1900s and still educates students up to the eighth grade today.

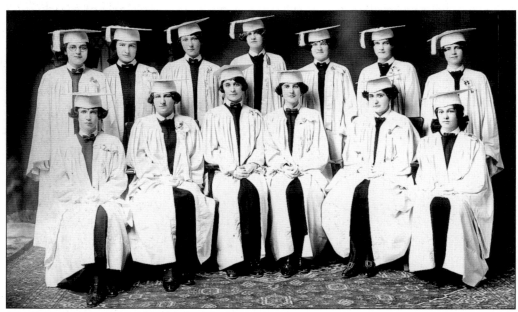

ST. ANNE'S ACADEMY. Established by Rev. J.Z. Dumontier, St. Anne's Academy quickly became a boarding school. The first diplomas were awarded in 1896. Testimony to the high standards of St. Anne's is its affiliation with the Catholic University of America in Washington, D.C., in 1953. Jennie Kelley is among the Class of 1925 shown here. The Sisters of St. Anne taught here as well as at St. Anthony's School, the first school at St. Mary's Parish.

REMINISCENCE. John A. Bigelow, Class of 1907, sketched this cover for his original poem written especially for his 50th class reunion. The Walker Building was half its size when it was his old high school, as shown. Bigelow wrote, "in my schooldays in a shoe-making town, the hickory stick had been supplanted for corporal punishment by a leather strap which had a louder tune from a softer impact." The Marlborough Public Library's auditorium is named for this active community leader who was most knowledgeable about local history.

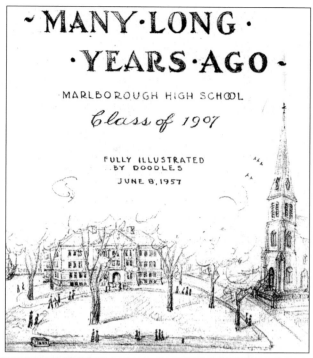

- MANY·LONG·
·YEARS·AGO·

MARLBOROUGH HIGH SCHOOL

Class of 1907

FULLY ILLUSTRATED
BY DOODLES
JUNE 8, 1957

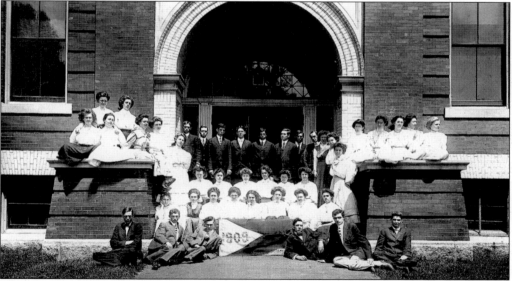

MARLBOROUGH HIGH SCHOOL CLASS OF 1909. Sprawling in the front row, third from the right, is a future mayor of Marlborough, Amedee Martel. Next to him is Howard Wilas. As mayor, Martel was the first to institute an official mayoral secretary. Mayor Martel had the Bigelow and Hildreth Schools constructed despite strong opposition. He was also general manager of the Automobile Legal Association. Standing in the back row are eight males in the doorway. The first young man on the left is Thomas M. Dacey, who was the eventual manager of T.M. Dacey and Son and city auditor. On the right, the girl standing up against the brick in front is Mary Fox, who became a French teacher in Marlborough.

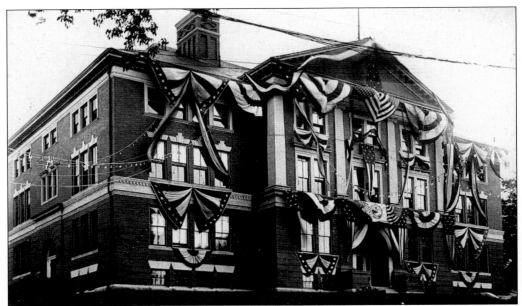

THE OLD HIGH SCHOOL IN 1910. For the 250th anniversary celebration of Marlborough's incorporation as a town, the high school was decorated, since it was the site of many festivities. Electric lights extended in streamers from the front and lit up the common and children's bleachers, as well as the governor's reviewing stand. All 600 lights were turned on for the first time at 8:30 p.m. one Saturday night.

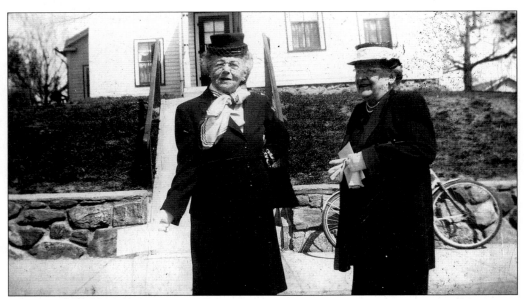

RETIRED TEACHERS. In the mid-1940s these two teachers, Margaret E. O'Brien and Esther G. O'Connor, walked back from church to their home at 37 Washington Street on Sunday mornings. Here they have passed in front of the Ledoux home near the McGees, Faheys, and Buckleys. O'Connor was a piano teacher and music supervisor who taught in Boston. She had a baby grand piano in their home. (Courtesy of Dick LaFreniere.)

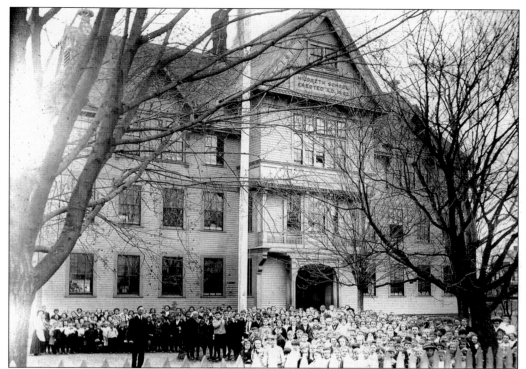

HILDRETH'S PUPILS AND STAFF. Half a dozen boys are playing piccolos in front of the flagpole. The old Hildreth School was erected in 1882 on the southeast corner of Church and Hildreth Streets. It contained 10 rooms, as did the old Bigelow School built the same year and with the same building committee of W.D. Burdett, James F. Murphy, and S.H. Howe.

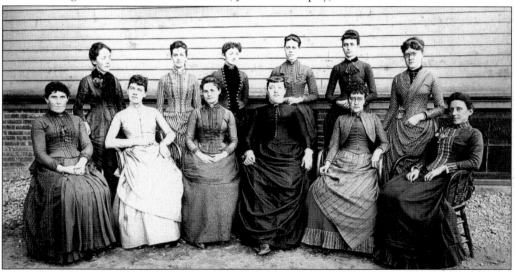

HILDRETH SCHOOLTEACHERS. These women were most likely unmarried, since married women typically could not remain teaching. This appears to be an earlier picture of some of the same teachers in the previous photograph. The name for both the school and the street comes from the old village doctor who had 14 children and lived on what became Hildreth Street.

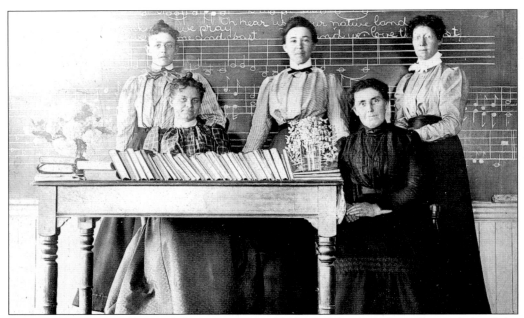

ON THE CLASSROOM FRONT. These women are Hildreth School teachers. Sitting behind the books on the left is Anne Wall. In the rear, on the right is Lillian Curtis, whose father served on the school board, owned a shoe factory, and was respectfully called "the deacon."

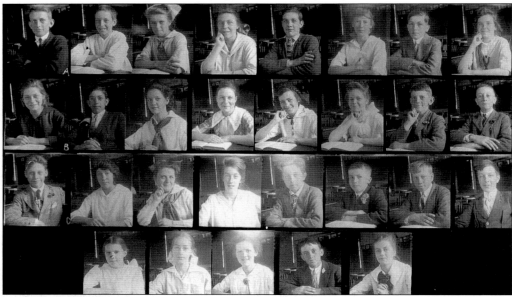

THE HILDRETH SCHOOL C. 1915. These Hildreth schoolchildren are, from left to right, as follows: (row D) Myrtle Wilbur, Grace Fuller, Ruth Babcock, Charles Morrow, and Laura Greeley; (row C) Mitchell Lord, Ada Blood, Sadie Billings, Grace Burhoc, Roy Hicks, Warren Spearel, Charles Gibson, and George Depate; (row B) Eleanor Bradshaw, unidentified, Marjorie Carroll, Hester Mckenzie, Evelyn Wright, Myrtle Sowerby, Waldo Holyoke, and Kenneth Logan; (row A) Leo Cocoran, George Blood, Doris Parker, Irene Cookson, James Sherman, Gladys Washburn, Harry Francis, and Hermine Kimmins, who was born in 1902.

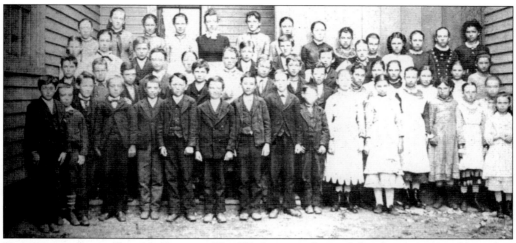

THE WASHINGTON STREET SCHOOL. The Washington Street School's name was changed to honor long-time teacher Bessie D. Freeman, and it was recently renamed the District Education Center. During the 1914–1915 mayoral tenure of Thomas O'Halloran, a loan was negotiated to construct the school, as well as a $17,000 loan to pave Main Street with brick from Howe Street to Maple Street. When Republican William Pine served as mayor, he built a walkway from Washington Street to Rice Street, across the Washington Street School's yard. The next mayor, Charles McCarthy, had Freeman Park built, which later became part of Freeman School grounds.

THE EARLY BAPTIST CHURCH. When first built in 1887, the First Baptist Church was painted darker than it is today but still in multiple hues consistent with the fanciful Queen Anne-style of Victorian architecture. Before its current color scheme, the First Baptist Church was painted white. This architectural style is noted for its varied shapes and textures in an asymmetrical design. Dwarfed in size by its close neighbor is the Marlboro Republican Club's log cabin, seen in the lower left-hand corner.

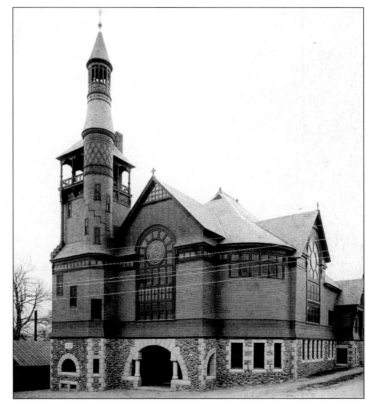

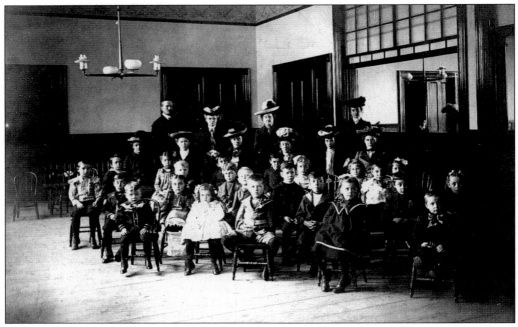

THE INTERIOR OF THE BAPTIST CHURCH. Davis and Whitman of Marlboro used the label "photographists" on the back of this photograph. The Victory Memorial Bell was added to the Baptist church in 1919 to honor the men and women who served and died in World War I. It is located on the corner of Witherbee and Mechanic Streets.

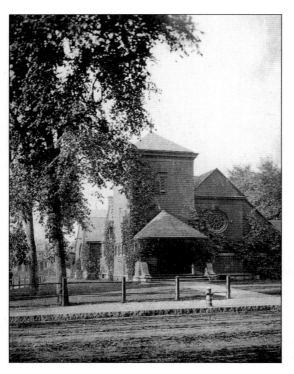

THE EPISCOPAL CHURCH ON MAIN STREET. Built the same year as the Baptist church but now gone, the Church of the Holy Trinity stood at the southwest corner of Main and Cotting Avenues, where Dunkin' Donuts is today. Its building and a future addition were gifts of Joshua Montgomery and Sarah C. Sears of Southborough. The Marlborough church sprang from St. Mark's church in Southborough and, in turn, helped give life to St. Luke's church in Hudson. The first rector lived on Hildreth Street but moved when the property was purchased for the Marlborough Hospital. A rectory was purchased on East Main Street. A cross serves as a memorial for church members buried in the parish cemetery located in the Rocklawn Cemetery.

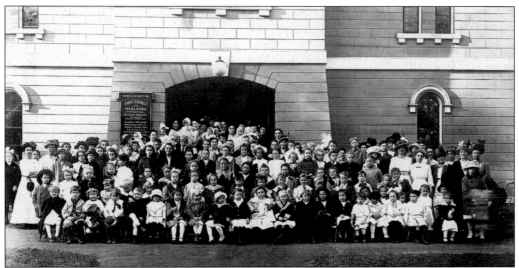

SUNDAY SCHOOL. When the First Church (Congregational) had this photograph taken, Rev. Albert H. Wheelock was pastor. The First Church is the earliest church in Marlborough. It was originally on the site of the Walker Building, when Colonists from Sudbury petitioned the General Court for an independent town. Then, it had a thatched roof and small, oil-paper windows. In 1853, the current building was erected at the corner of Bolton and High Streets, above the Union Common, which it owns. The Hurricane of 1938 blew off the steeple. A Bulfinch belfry was added in 1940.

THE IMMACULATE CONCEPTION CHURCH AFTER THE HURRICANE. In 1869, the Immaculate Conception Church was damaged by lightning. A tower, bell, and spire were added in 1886. The church was once again a casualty of the forces of weather when its 100-foot steeple was knocked over by the Hurricane of 1938 onto the house next door. There is a workman straddling the very top.

A FORMAL OCCASION. In 1902, George Lizotte Sr. posed for a formal picture, perhaps in honor of a youthful religious milestone. Most of the French Canadians settling in Marlborough were Roman Catholics. At first, they attended the Catholic church organized by the Irish immigrants on Washington Street. Then they created their own church on French Hill, with masses spoken in French. (Courtesy of Kathleen Lizotte Lynde.)

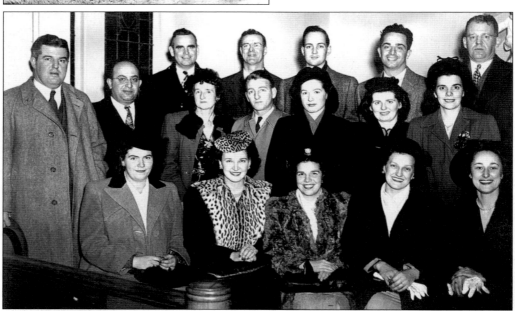

THE DEDICATION OF THE IMMACULATE CONCEPTION CHURCH. In the mid-1940s, the Immaculate Conception Church, on Prospect Street, was dedicated with the following people in attendance, from left to right: (front row) Kate Buckley Avey, Marie Burke Maslowski, Miss Flanagan, Miss Maslowski, and Mary Provasoli; (middle row) Charlie O'Connell, ? Ricciutti, Dorathea Burke (organist), Sy Kenny, Madeline Francione Dudley, Virginia Johnson, and Mary Rossi; (back row) T. Joseph McCook, Louis Collette, Ellery Hurd, Nick Ricciutti, and John O'Connell.

Eight
HOW TO
PLAY THE GAME

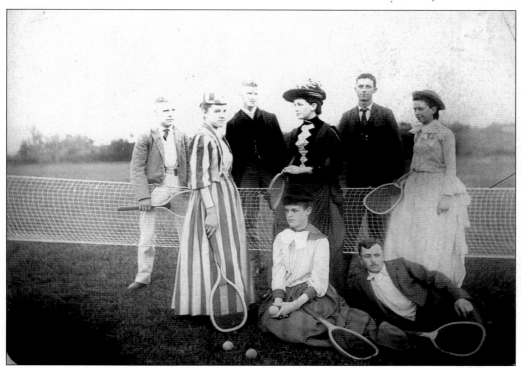

LAWN TENNIS, ANYONE? Tennis was a social game when it began in England and Boston in the summer of 1874. High heels, picture hats, veils, and corsets were worn by female players. The first tennis balls were covered in flannel.

BOXING IN STYLE. Frank White of Brockton (left) spars with George C. Lizotte Sr., who lived in the same shoe town before his family moved to Marlborough. (Courtesy of Kathleen Lizotte Lynde.)

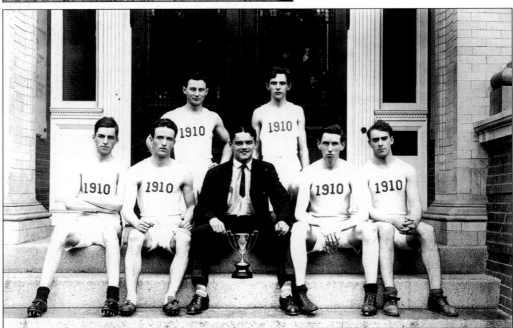

1910 TRACK CHAMPIONS. These 1910 track champions are, from left to right as follows: (front row) Stanley B. Freeborn, Joseph P. Drummey, John C. Ward, Joseph P. Lynch, and Henry E. Berger; (back row) Bernard W. Dezotell and Hollis H. Tayntor. Walter "Woggie" Williams took this photograph.

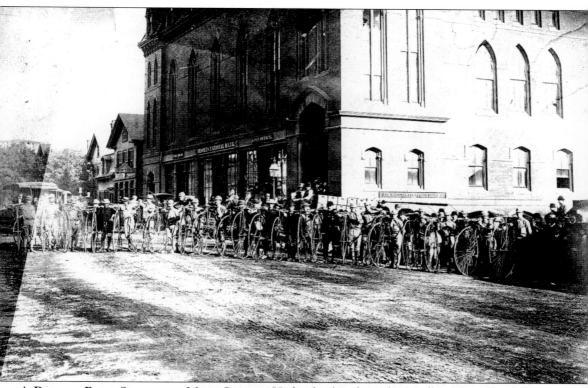

A BICYCLE RACE STARTS ON MAIN STREET. High wheelers from the Marlboro Bicycle Club are in front of the old town hall on October 24, 1880. Leslie Frye was a member who won racing medals. The club held dances, too. Listed inside its 1881 dance card is the order of dances, such as the Portland Fancy, Money Musk, the schottische, and bicyclists' choice.

HAROLD BROWN. A star athlete, this high school football player was called "Deacon." When he graduated and began coaching at the high school with his younger brother Frank on the team, the nickname was transformed into "Little Deac" for his sibling who was shorter. Notice his folding football helmet. (Courtesy of Dick LaFreniere.)

THE 1914 FOOTBALL TEAM. Sitting on the old high school steps in the front row are, from left to right, James McDonald, unidentified, Henery LaForme, Orai Piloquin, William Goggin, Harold "Deacon" Brown, and unidentified. Sitting in the second row, from left to right, are Ralph Longley, Harold Morse, Marshall Balfour, Fred Claflin, unidentified, Walter Carroll, and unidentified. Standing in the rear are unidentified, Ralph Delorey, coach George Hayes, unidentified, and Walter Lepper. (Courtesy of Paul H. Hayes.)

HILLSIDE FOOTBALL. The undertaker, Mr. Tighe, owned and operated the school bus, which would stop at Hanley's Corner to pick up older Hillside School residents attending Marlborough High. J.M King rode the bus, and one day he invited the other boys to come play baseball down on Robin Hill Road. After church on Sunday afternoon, high school students arrived in several cars they drove themselves. They wore uniforms and had catcher's mitts, 6 to 12 baseball bats, masks—even chest protection. Even though the Hillside kids only owned a few gloves, they still ended up winning a few games. When activities escalated to sports contests, such as the high jump and pole vault, the Hillsiders were really at a disadvantage. Later, when a football game was planned, several Hillside students sobbed when they spotted the Marlborough High School team arriving outfitted with helmets, pads, and several real footballs. All Hillside had was one lumpy football that was taped at both ends.

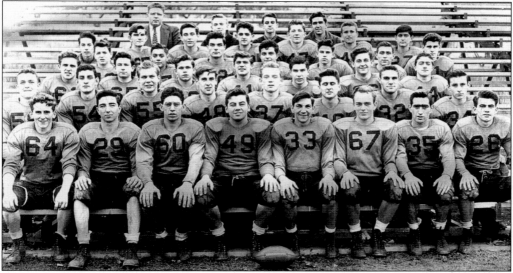

M.H.S. FOOTBALL 1948. Taken by eminent domain from the Tayntor estate, Marlborough High's home field was Ward Six Playground, shown here, and now named Kelleher Field. Pictured from left to right are the following: (front row) Dick Muti, Jack Kelleher, Emile Bedard, Bill "Ace" Donahue, Peter Panagore, Seth Carpenter, Richard Sullivan, and Fred Baker; (second row) Joe Granger, Emilio Pazzanese, Clyde Johnson, Richard White, William Donahue, Bill Hutch, Gus Garceau, and Dick Burns; (third row) Jack Tanna, Jim Lenihan, Dick LaFreniere, Joe Valianti, John DeBarios, Frank Masciarelli, and Massimo Valianti; (fourth row) Paul Sullivan, Joseph Cavichi, Don Jolie, David Piper, Buckle Dudley, Eddy Ledoux, and Al Durand; (fifth row) Dona Bouchaine, Charles Giorgi, John Tyan, Jim Torres, Dick Nanartowich, James Drummey, and John Casaceli; (sixth row) coach Leo Brennan, manager Dick Brigham, assistant manager Fred Giancola, and George Ferruccio, injured.

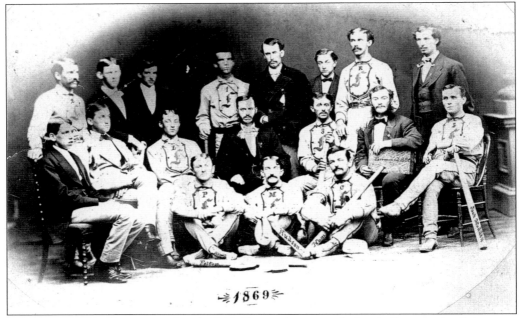

THE FAIRMOUNT BASEBALL CLUB 1869. Pictured is an early baseball team, the Fairmount Baseball Club, in 1869. Someone has inked their positions on their jerseys. Some of the players' names are listed on their bats.

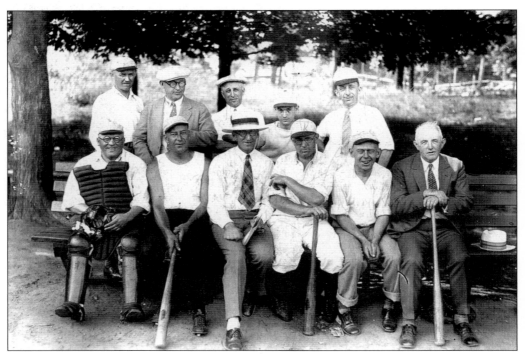

CITY HALL BASEBALL. City hall employees enjoy an outing at Lake Quinsigamond Park c. 1947 with a baseball game against the Electric Light Company.

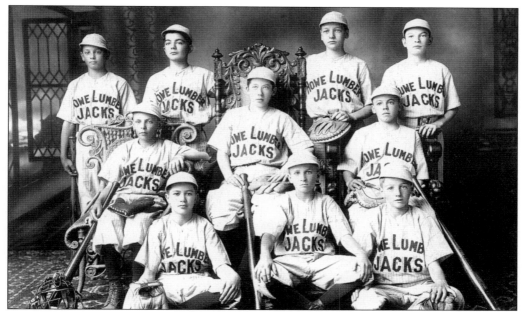

THE HOWE LUMBER BASEBALL TEAM. The Howe Lumber baseball team is pictured *c.* 1919. From left to right are the following: (front row) Babe Kane, Alfred Pease, and Cy Kenney; (middle row) ? Hayes, Pooch Bracken, and John Williams; (back row) Harry Bonin, ? Margadonna, Harold Jenkins, and Doug Blais.

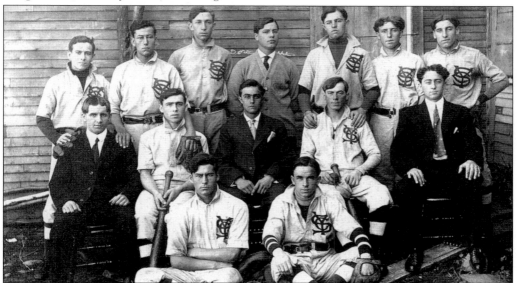

THE YOUNG SPORTSMEN'S CLUB. Initials of the Young Sportsmen's Club are superimposed upon each other to form the insignia found on the shirts. This organization is affiliated with the L'Union dramatique et litteraire. Leo Maybay is wearing a dark cardigan in the center, behind Judge Edward T. Simoneau. Sitting in a chair on the far right is Archie Cormier, former owner of the Cosy Café on Lincoln Street. His family home was around the corner on Gibbon Street. In the third row are two Gaucher brothers: second from the right is Ovila (Pat) and on the far right is Joseph. Notice the difference in surroundings from the previous photograph.

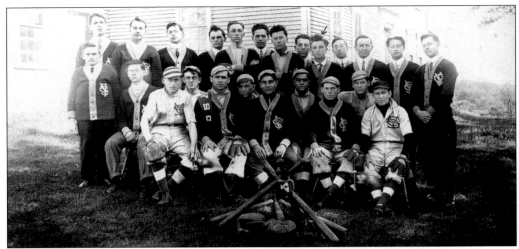

THE YOUNG SPORTSMEN'S CLUB BASEBALL PLAYERS. A pointer to the back row indicating Grandpa Pat (Ovila Gaucher) has been inked in. On the far left in the front row is the catcher, wearing the striped cap. Notice his thin mitt, as well as the others. On either side of the tepee of bats are thin canes flying blurred flags with a "Y" on them.

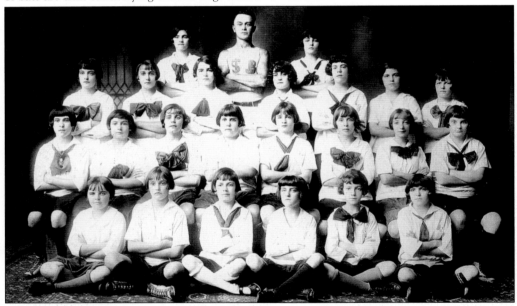

STEVENS' PLAYGROUND GIRLS. The volleyball champions of the summer of 1926 were coached by George C. Lizotte Sr. (rear center). The second row includes Eleanor (Leduc) Paulausky, Lorraine Leduc, Helen Zanca, Doris (Phaneuf) Sandini, Irene (Werner) Figuirido, Helen (Asselin) Jones, and Irene (Scott) Laverdure. In the other rows, from left to right, are the following: (first row) Doris (Zanca) Sawyer, Eleanor Emery, Neida (Roberts) Callahan, Marguerite (Lombardi) Bushey, Eileen Hallowell, and Irene (Lacouture) Columbe; (third row) Marjorie (Emery) King, Hazel (Duplessis) Paquin, Kathleen (Werner) Harpin, Amelia Lombardi, Anita (Rougeau) Naves, Annette Rougeau, and Venita (Girouard) Cloutier; (fourth row) Jennie Cincotta, coach Lizotte, and Eleanor (Landry) Fiske. Charlotte H. Stevens owned the land when the playground was built on French Hill. (Courtesy of Kathleen Lizotte Lynde.)

PLAYING BALL ATOP SLIGO HILL. With Lake Williams in the distance, a left fielder heads southeast, while men and boys enjoy a game at Stevens Playground. The smoking chimney is from the pumping station, still on Route 20. Mayor J. Henry Gleason (1912–1913) facilitated a 15-year lease of this land for a playground. Charlotte H. Stevens was the landowner. (Courtesy of Kathleen Lizotte Lynde.)

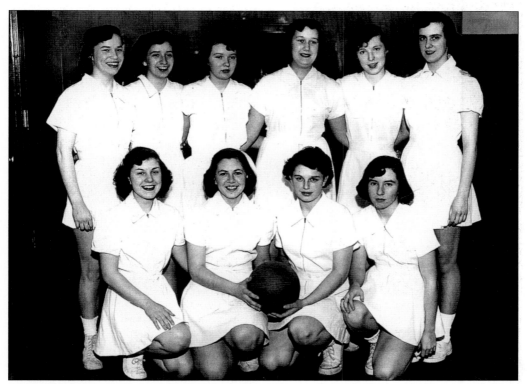

GIRLS BASKETBALL. From right to left are the following basketball players: (front row) Chris Hassapes, Pat Livernois, Gail Mantha, and Jackie Wallace; (back row) Lorraine (Wheeler) Quaglia, Joyce Hudson, Helen Carr, Margie Mally, Martha Himmelman, and Nancy E. Brown. Except for Gail, who was in the Class of 1956, all of these players graduated in 1955.

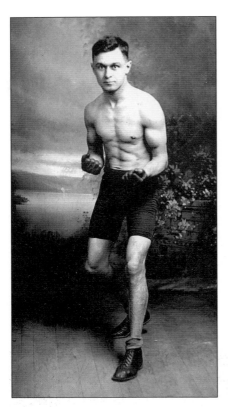

BANTAM-WEIGHT BOXING CHAMPION. An all-around athlete, George C. Lizotte Sr. participated in many sports, both as a player and an instructor. About the time of this photograph, "the Banty" had won the Boston Athletic Association Sparring Open Class of 1908 at the age of 20. Lizotte was also known for running five- and ten-mile races. He died in 1967. (Courtesy of Kathleen Lizotte Lynde.)

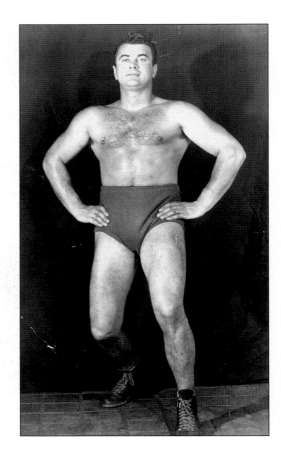

MR. PHYSICAL CULTURE. Arthur Kapitanopolis was a wrestler in the 1940s and "Kappy" was his nickname. He was named "Mr. Physical Culture" in magazines.

102

Nine
WAR

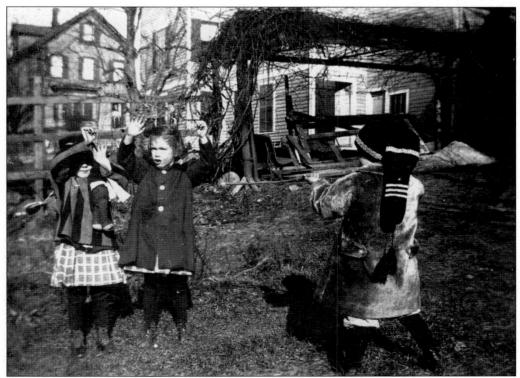

STICK 'EM UP! Neighborhood children are playing a game. Francis Brown is holding up Annie Cleary and Dot Herrick *c*. 1903. Little does he know, his picture is being taken. Cleary was born in 1897. This is perhaps the Greenwood Street area. (Courtesy of Dick LaFreniere.)

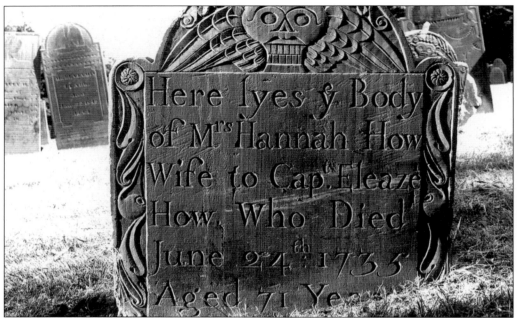

SPRING HILL CEMETERY. The motif of a winged skull flying toward heaven became a sweeter looking cherub on later gravestone engravings. Every Memorial Day, veterans' graves are decorated with flags and markers. Even though Hannah Howe's military husband died in 1737, before the United States was established as a nation, his slate marker is honored on the holiday once known as Decoration Day. The oldest gravestone in Marlborough, for Capt. Edward Hutchinson, who died 17 days after being attacked by Indians in 1675, is also decorated to signify a soldier's sacrifice for independence in this cemetery above High Street. The small slate marker is encased now in a more solid, modern stone to better protect it.

ARTEMUS WARD PARK. Although these are veterans saluting during much more modern times, at the 1955 Labor Day parade, there is a connection to the Revolutionary War. The Artemus Ward Park is named after the commander in chief of George Washington's army. From left to right are Walter Huntington, Fritz Anderson, Mrs. Kelleher, and Jerry Bradley.

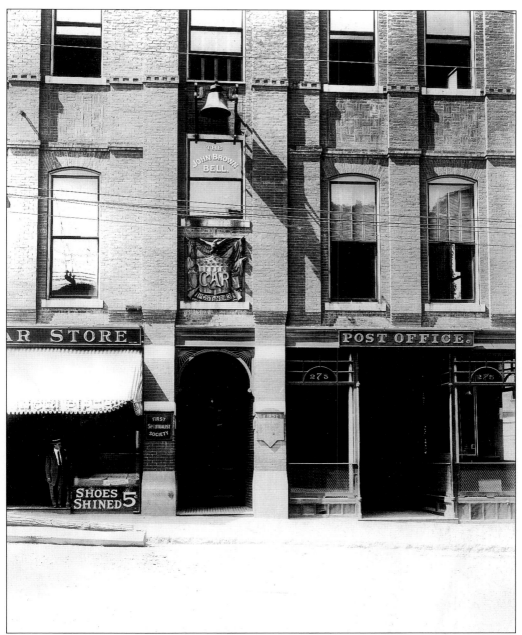

THE G.A.R. BUILDING. On the northwest corner of Rawlins Avenue and Main Street was erected this meeting place for Post No. 43 in 1891. The John A. Rawlins Post was chartered in 1868 to serve soldiers who fought in the Civil War. The original plan was to name the post after Lincoln, but it was renamed when a local soldier died. When the John Brown Bell was retrieved from its hiding place and finally brought to Marlborough by nine of its original captors, it hung out front above the Main Street entrance. It was not until the summer of 1968 that the famous bell was moved inside a tower especially built for it on the Union Common by the intersection of Route 85 and Main Street.

No Bell. This photograph was taken before the G.A.R. hung the John Brown Bell on its new building in 1892. It shows a plain glass window above the ornate emblem for the organization. An eagle, flags, stars, and rifle butts make up Post No. 43's sign. Later, the window was opaquely painted with the words "The John Brown Bell." The post office, newspaper offices, a cigar store, two more local veterans groups, and other businesses all took up residence in this Main Street building. The cornerstone from the now-demolished G.A.R. building sits on the side lawn by the entrance to the Peter Rice Homestead on Elm Street, property of the Marlborough Historical Society. Upon learning from the public library's microfilmed newspapers that a box was placed inside the stone in 1891, former curator John Moran and society member Lindley Felton pried it open. Inside, a G.A.R. membership list and medals, such as one from the 1891 National Encampment in Detroit, were found.

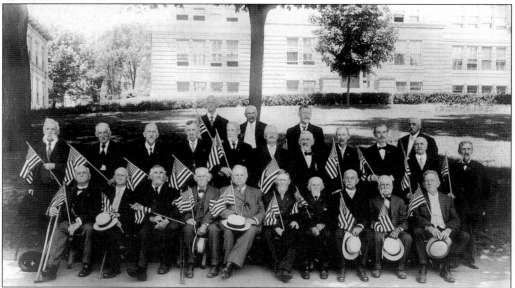

The Grand Army of the Republic. Marlborough's Civil War Veterans pose on the lawn of the Walker Building, next door to their group's headquarters, which faced the Soldiers Monument erected in their honor. This photograph was created in the first decade of the 1900s. The large building was used for the high school. The building on the left edge is another school, which was later removed.

THE SOLDIERS MONUMENT.
Decorated with the names of Marlborough men who fought in the Civil War, as well as the well-known battles they may have fought in, this obelisk is topped by an eagle. It was dedicated in 1869. Rifles, an anchor, and other military icons grace the sides. Steps, manicured shrubs, and well-kept flowers surround the monument today, but there is no longer the wrought-iron fence. From left to right in the distance are the First Baptist Church, the intersection of Witherbee and Mechanic Streets, the Peoples National Bank, and the Natural History Museum on Gay Street. Monument Square was once called School House Square, since it had, at different times, four schools before 1816, including the Centre School. The square is actually shaped like a triangle.

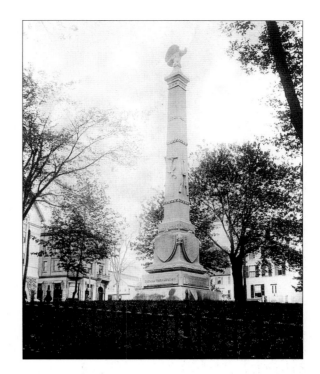

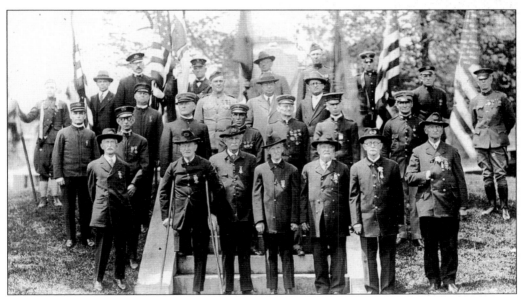

THE CIVIL WAR, SPANISH-AMERICAN WAR, AND THE GREAT WAR. Veterans from three wars stand at Monument Square. From left to right are the following: (front row) unidentified, one-legged Lafayette Stickney, John Biggs, George Brigham, John McCrellis, Stillman Woods, and unidentified; (second row) ? Hudson, three unidentified veterans, Charles McCarthy, unidentified, and Harold Brown. In the third row are an unidentified American Indian, deputy U.S. marshall Christopher Ghiloni (wearing a suit and tie), and Edward Cushman.

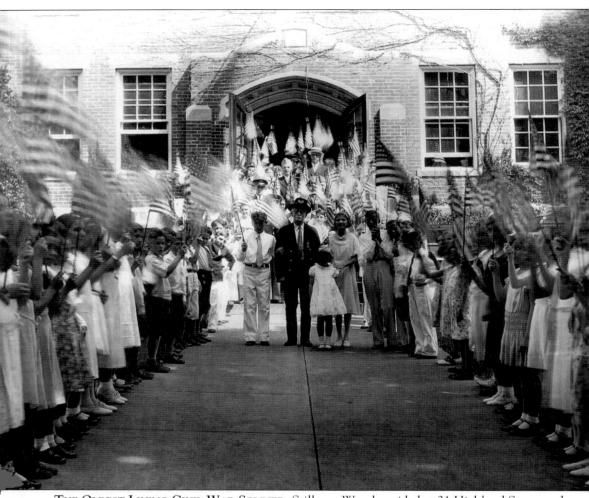

THE OLDEST LIVING CIVIL WAR SOLDIER. Stillman Woods resided at 21 Highland Street and was part of the regiment that took the John Brown Bell from Harper's Ferry, West Virginia, after the war was finally over. Buried in a canal boat owner's yard in Williamsport, the bell was not retrieved until more than 30 years later, when Marlborough G.A.R. soldiers were attending a convention. It is named for the fervent abolitionist John Brown whose dream was that some day the bell would ring and ring and all slaves would be free.

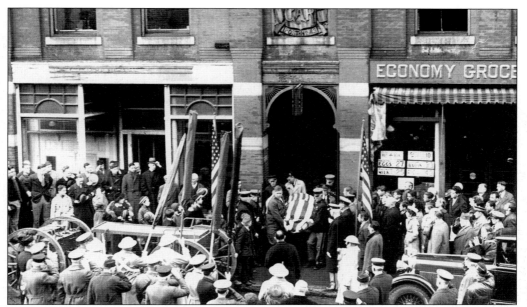

THE LAST LIVING G.A.R. MEMBER. When Stillman Woods died in late winter of 1937, he was the last Civil War soldier still alive from Marlborough, of the 869 who served. In this shot, his flag-draped casket is being carried out from the G.A.R. Building, under the John Brown Bell, which is just above the Post No. 43 sign. Woods' regiment victoriously took the bell as part of the spoils of war with permission from the War Department. Harper's Ferry periodically pleads for the return of the bell.

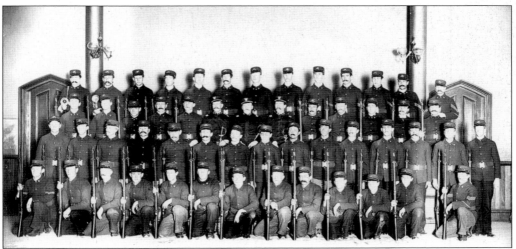

COMPANY F IN CITY HALL. Fifty-four men and officers of Company F, 6th Regiment of the Massachusetts Volunteer Infantry, pose in the armory at the old city hall on May 6, 1898, before heading off to fight in the Spanish-American War. Present are two lieutenants and Capt. Thomas E. Jackson. The soldiers had marched up Main, Mechanic, Prospect, Broad, East Main, and finally, ended here, where they heard Mayor Eugene Hoitt's send-off speech. It is said that 15,000 people gathered to see them off. A special train took them to Camp Dewey in South Framingham and then to Camp Alger in Virginia.

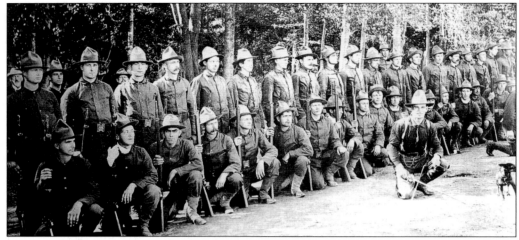

MARLBOROUGH'S SOLDIERS IN VIRGINIA. Shown here is Company F at Camp Alger, where President McKinley reviewed the men. After taking trains to Charleston, South Carolina, the volunteers boarded ship for Puerto Rico to defend Cuba from Spain. They were in the line of reserve during the battle of Santiago and fought in the battles of Guanic and Yauco Road. The mission was accomplished in four months. Diarist George B. Herrick and fellow Marlborough soldiers returned home October 27 of the same year. They landed at New England Wharf Pier No. 4 and marched around Beacon Street in Boston before boarding a train at Union Station. Upon arriving in Marlborough that evening, the soldiers marched to the armory where they were feted.

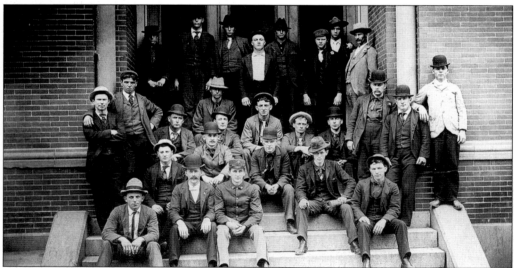

A SECOND CALL. More men joined Company F, 6th Regiment of the Massachusetts Volunteer Infantry, on May 25, 1898. Not all are in this photograph by Albert H. Wade of Marlborough. Pictured are the following: Riley Berry, David Bishop, Armos Bonin, Wallace Burhoe, Frank Chartier, Edmund Clements, George Cutler, Michael Colleary, Wilinot Duley, Frank Estey, Fred Estabrook, Arthur Faulkner, William Fay, John Greene, John Groner, Wilfred Gour, Ernest Howard, Robert Lee, Dosithe Lafay, Louis Heurex, Edward Lovely, Timothy McGee, Thomas Mullen, Joseph O'Clair, Penny Palardy, Clarence Rowles, Henry Rowles, Harry Ruggles, Louis Sasseville, Harry Taylor, Harry Willard, and Irving Wright.

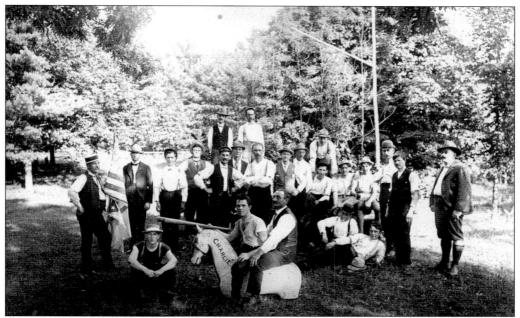

FOURTEEN MONTHS LATER. Many of the Spanish-American War veterans from Company F enjoy an association meeting at Gates Pond in Berlin after serving in southern climates. The date is July 25, 1899. Most of the men look thinner after many meals of hard tack and exposure to malaria. The United States won Guam, Puerto Rico, and the Philippine Islands in the war and emerged as a world power.

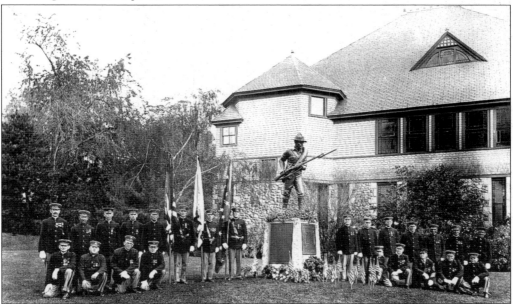

THE SPANISH-AMERICAN WAR MEMORIAL. A tall, thin local man posed for this statue, *The Sentinel*, which stands by the First Baptist Church near the public library. The Marlboro Republican Club's log cabin was once located here. The smartly outfitted Company F, 6th Regiment, soldiers became highly regarded throughout the commonwealth.

PRINCESS THEATRE

STARTING

Sunday, Monday and Tuesday
April 8, 9 and 10

Now you can see them
on the screen!!

UNCENSORED
· AND ·
SUPPRESSED
WAR FILMS

The Sensational Films they said
could never be shown to the public.

You'll shout·· *To hell with Glory*
when you see it:·

"Forgotten
Men"

WAR AT PRINCESS THEATRE. The flyer from one of Marlborough's movie theaters promotes 10¢ matinees in 1934. These reels were shot by the U.S., Allied, and German governments. Included were Zeppelin raids over London, U-boat and submarine warfare, and "gas-liquid fire-death." The Warren Block at 155 Main Street was built on the site of the old Princess Theatre.

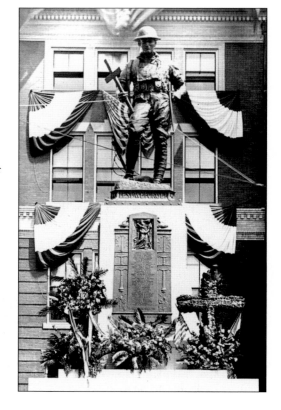

A DOUGHBOY POSTCARD. John G. Hardy of Providence sculpted this bronze statue of a soldier on the battlefield of World War I, or the World War, as it was once called. The larger-than-life figure was initially sited on a blue and white Westerly granite base closer to the Walker Building, which was then the high school. It was dedicated on the Fourth of July in 1923, with Judge James W. McDonald of Marlborough presiding after a parade. Memorial wreaths from several organizations were placed at the close of the ceremony. Arriving the day before was a group from Camp Devens (the future Fort Devens and then later, Devens). (Courtesy of Marlborough Public Library.)

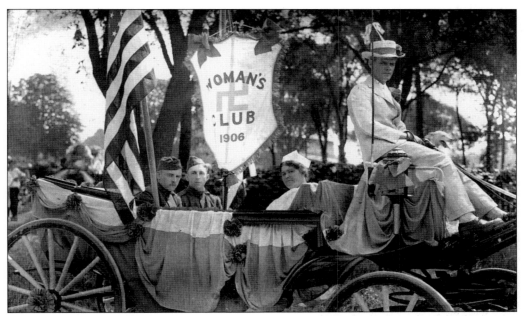

Two Soldiers in a Woman's Club Carriage. When World War I ended, the soldiers who fought were honored with a big parade in 1918. All along, volunteers mailed cards and packages to the Marlborough men and remembered the families who lost loved ones to the war.

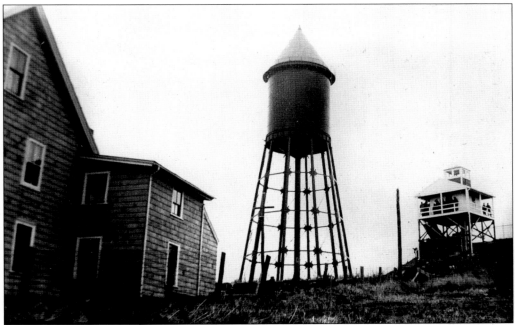

The Standpipe and Lookout Tower. In 1942, it was necessary to watch out for enemy airplanes during World War II. Mount Sligo, or Sligo Hill, was then considered the highest point between Boston and Worcester. It is 1,500 feet above sea level. The tower is no longer standing. Another lookout was manned by local veterans during daylight hours off Phelps Street.

SCHOOLS AT WAR. The Bessie D. Freeman School received a citation from the United States Treasury Department for its participation in the Schools at War Jeep Campaign in the War Savings Program. On the document, dated April 19, 1943, are four stars for four jeeps. Formerly the Washington Street School and now the public schools' administrative offices, the Freeman School was named after a teacher who had taught for almost half a century.

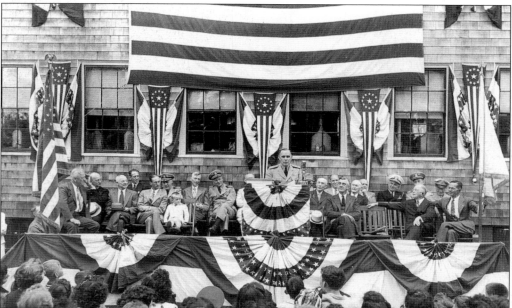

THE CURTIS SHOW REVIEW STAND. In the mid-1940s, Curtis Shoe sponsored this World War II event. Only women and children are below, listening intently. This photograph was given to the society by the daughter of Helen Clarke, who worked at Curtis. The Curtises were involved in the shoe industry in the early 1800s. John Curtis, a community leader, was a foreman in John M. Boyd's factory, but soon partnered with Henry C. Curtis, his brother.

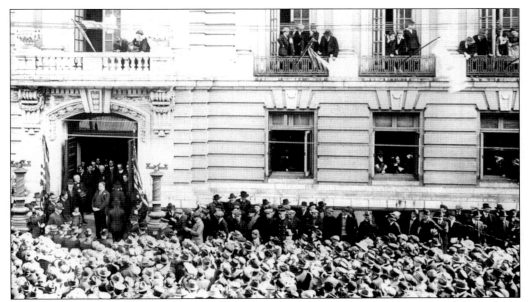

THE WAR IS OVER. When peace was declared, the entire Main Street area drew a throng that wanted to hear that World War I had ended. Local dignitaries assembled upon city hall's steps on April 27, 1918. Five or six aging veterans from earlier conflicts form a compressed line on the bottom step to face the speaker.

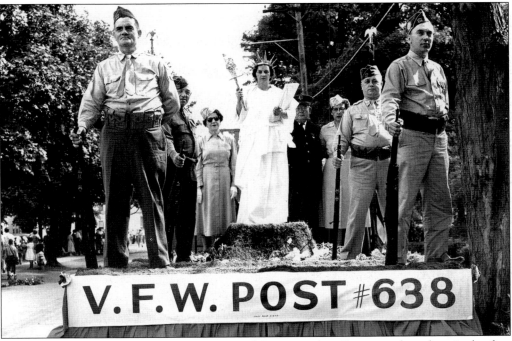

A LABOR DAY PARADE FLOAT 1955. Lionel Beauregard, a sheet-metal worker, is the first veteran on the right. The short man behind the veteran on the far left is Dwight Ferden. The Veterans of Foreign Wars Post No. 638 hired Post Road Signs to create this banner for its float. A woman is portraying the Statue of Liberty.

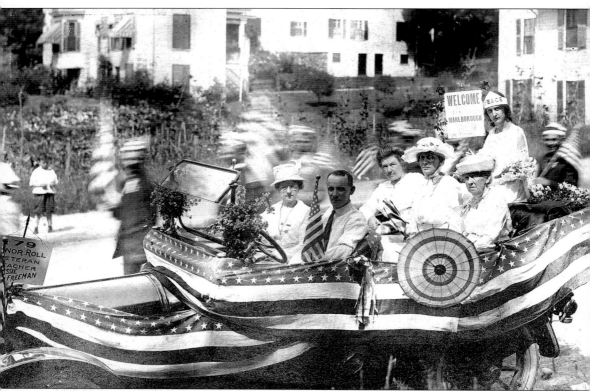

PEACE. To celebrate the end of World War I, Marlborough hosted a parade. The woman wearing "PEACE" upon her crown is holding both flowers and a sign saying "Welcome Home Marlborough Men." When Arthur S. Adams, a Worcester photographer, took this picture the shutter speed was too slow to freeze the waving American flags or the five or six exuberant marchers passing by the stationary motor vehicle. The community had lost 37 soldiers. At the Fourth of July exercises in 1919, Mrs. Churchill played the part of the Goddess of Liberty. Lt. William H. Finn Jr. addressed her with these words: "Goddess of Liberty, thou guiding staff of our Republic, crown this memorial to our dear soldiers with the victor's wreath." He continued by stating that our country's mandates still "make heroes assemble when Liberty's form stands in view. Its banners make tyranny tremble when borne by the Red, White and Blue."

Ten
JOIE DE VIVRE

PLAYING CARDS. Card playing was a common pastime in early Colonial taverns. However, this is an 1899 game with A.J. Bigelow and C.B. Lawrence. Note the abundance of pictures, both printed and original, inside this home. When advancements in publishing made detailed, colorful illustrations possible, there was an explosion of visual information that forever changed the world.

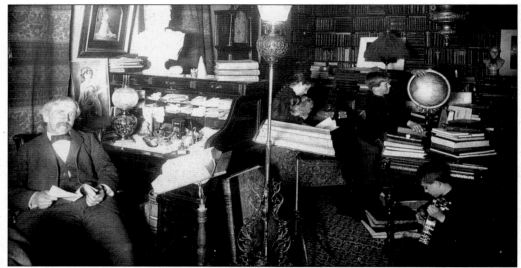

INDOOR ACTIVITIES. Literature, geography, travel, art, and music were all enjoyed by the Bigelow family. It is no surprise that writing and journalism continued to be common family occupations. Alden and Olivia Bigelow's son Richard A. Bigelow, along with Charles F. Morse, established the *Times* at Forest Hall in Marlborough and moved it to the Corey Block in 1871. This is before Peter B. Murphy took over in 1891.

EVA AND FLORA LIZOTTE. In a second photograph by Hatstat Studio, these sisters have exchanged dresses. An experienced seamstress has done the appliqué. The 1866 directory describes an important invention that may have helped. Elias Howe Jr. of nearby Westborough had patented the sewing machine, made with replaceable parts. "Merchant tailors, boot and shoe manufacturers, pantaloon and vest makers" found that Howe Machines "are much less liable to get out of order." Eva (left) later married Arthur Rougeau, who ran for mayor in Louis Ingall's time.

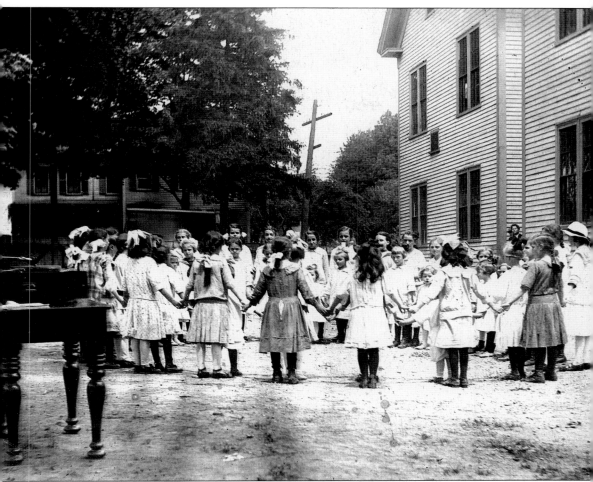

MUSIC EDUCATION. At the old Pleasant Street School, the girls are having fun on the tar playground. A turntable is playing records on the cabinet on the left. Later, the John J. Mitchell School replaced this school at the corner of Elm Street. Thomas P. Hurley was contractor for the Mitchell School in 1925.

MR. AND MRS. HOWE. The photographer's in-laws are George Windsor Howe and Clarissa Ann (Wyman) Howe, parents of Nellie Frances (Howe) Tayntor. The occasion is their 50th wedding anniversary in July 1901. Another daughter was Alice C. Howe.

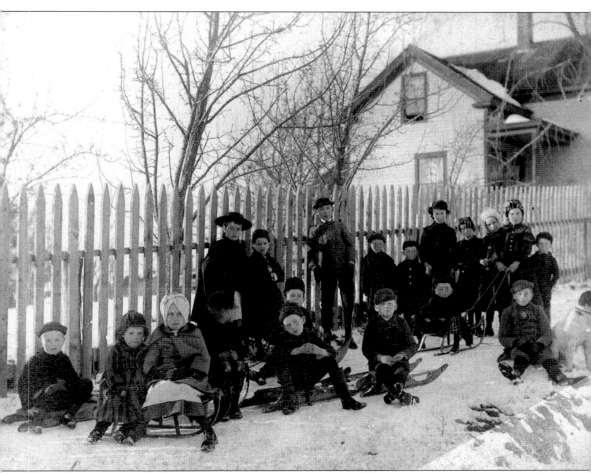

SLEDDING DOWN HIGHLAND CITY'S HILLS. One of Dr. John Rock's fondest childhood memories was sledding on the slopes of Marlborough. To capture this image in the 1890s, the children had to keep very still. Joseph Tayntor experimented with different photograph techniques and shared his interest with professional photographer Edward P. Richardson, who did his portrait in the 1880s, when Tayntor was 25 years old. Snowshoeing, sledding, and cross-country skiing are fun, but they are also means of transportation when working around acres of farmland like these boys—who resided at Hillside School on Robin Hill Road—did. "D.A.R. mittens were a godsend if made of wool, even wet," remembered former Hillsider J.M. King.

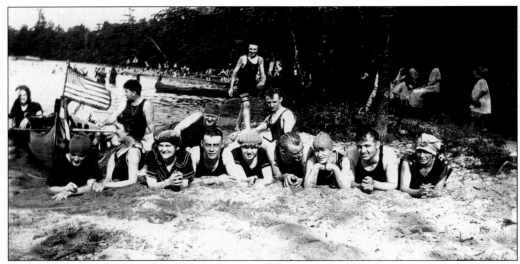

FORT MEADOW FUN. At the turn of the 20th century, bathing costumes covered up much more than they do today. Docks, rafts, canoes, and benches made Indian Lake, as it was then known, easier to enjoy. A public beach opened at Fort Meadow in 1923. Originally called Savages Beach, it was later known as Moriaty's Beach and then World War II Memorial Beach. (Courtesy of Paul H. Hayes.)

INSIDE THE LYONHURST BALLROOM. Jimmy Dorsey, Cab Calloway, Louis Grimes, Harry R. Wheeler and his orchestra, Frank C. Sheridan of Maynard, and Artie Shaw and his orchestra all filled the house at "New England's Largest and Most Beautiful Ballroom." Film heartthrob Rudolph Valentino appeared here. Later, roller-skating and boxing matches became popular activities. Before the Lyonhurst burnt down, it was located on Williams Street across from where the Marlborough District Courthouse is today.

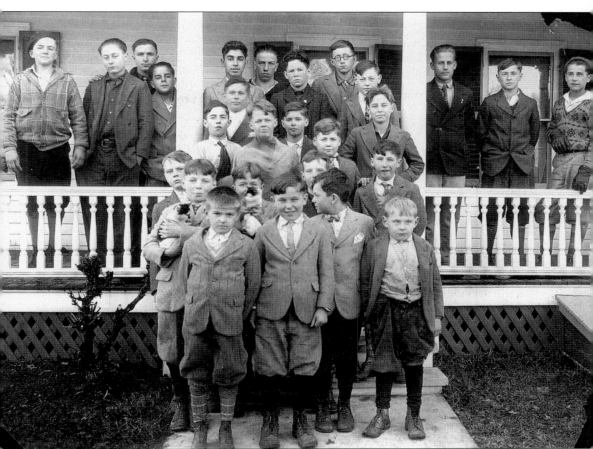

LIFE IS WHAT YOU MAKE IT. In its beginning, Hillside School for Boys, as it was called then, served orphans and lads from challenging circumstances. Clothes were shared and mended repeatedly. Tending livestock, growing fruits and vegetables, canning, and milking cows have proven to be practical formulas for ensuring that these young men will thrive in life, despite early hardships.

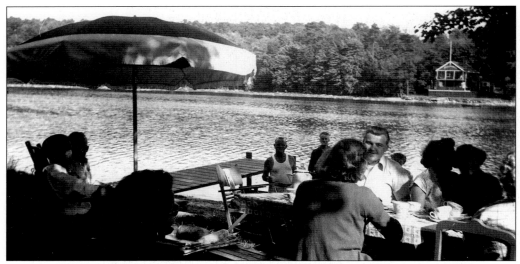

THE NEBAGONGA CLUB. Al Krugley is at the Nebagonga Club's boathouse on Fort Meadow in the early days. In 1953, the city purchased 13 acres with 800 feet of frontage on Fort Meadow from Stow's C.D. Fletcher and the American Woolen Company, which had bought water rights to ensure its Maynard mills would have water power. Other swimming spots included "sollies" at Solomon Pond and Millham Reservoir, where there was an island. (Courtesy of Richard Peters.)

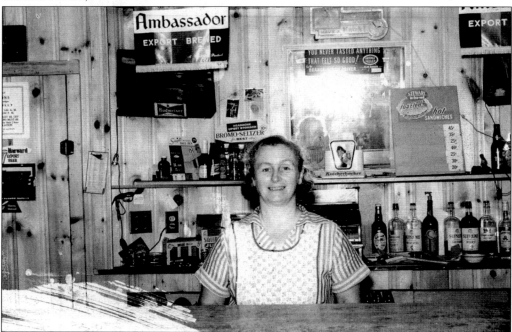

THE WILLOWS. Gwendolyn Ernestine (Brown) LaFreniere is ready to serve. Located at 400 South Street from 1955 to 1958, this bar was next to Dairy Freeze, which sold ice cream. The large building included LaFreniere Television Center, which had previously been located on Main Street as well as Bolton Street. Now this location is the site of Capello's 495 Trucking Center. (Courtesy of Dick LaFreniere.)

A Totem Pole. Edgar Gadbois is on the left, behind Ronny St. Michael, age 13, who is behind Bobby Werner, age 12. Holding up Bobby is Ronny LaFreniere, age 13, who is being held up by his 14-year-old brother Dick. All the boys resided on Washington Street except Bobby, who lived around the corner on Devens Street. The date is August 22, 1948. Both Edgar and his father Romeo served as mayors. Ronny and Dick's father made an unsuccessful bid for mayor against Romeo Gadbois. (Courtesy of Dick LaFreniere.)

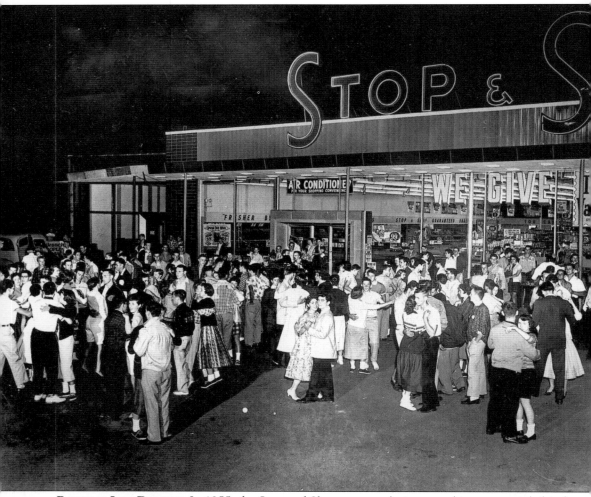

PARKING LOT DANCES. In 1955, the Stop and Shop grocery chain opened its new store behind where the second McDonald's on Maple Street was erected, as well as where the *Marlborough Enterprise*'s first Maple Street building was. The store sponsored an outdoor dance as a promotion. Dancers wearing white ankle socks were called "bobbysockers." On Marlborough's AM radio station, WSRO, disc jockey David Muise had a popular golden-oldies show, which included swing-era tunes. (Courtesy of Dick LaFreniere.)

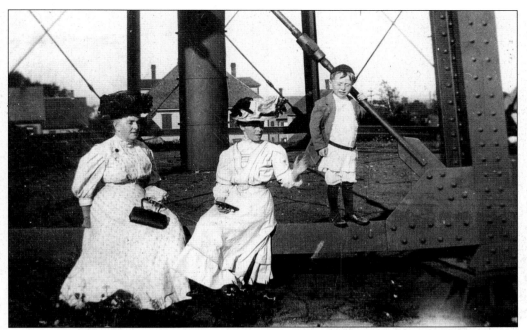

ON THE STANDPIPE BASE. Harriet Tenney of Church Street and her friend Daisy Brown have strolled 1,500 feet above sea level with young Francis Brown. They are resting on the base of a well-known landmark in 1909. The next year, for a whole week before Marlborough's 250th anniversary, "the standpipe was brilliantly illuminated with festoons of lights which could be plainly seen evenings for many miles around. This was one of the marked features of the celebration," wrote Ella Bigelow. (Courtesy of Dick LaFreniere.)

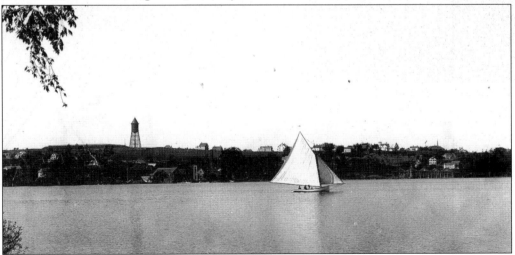

SAILING ON LAKE WILLIAMS. This photograph was taken from the Worcester and Marlboro Street Railway coming into Marlborough. It shows the standpipe overlooking the body of water labeled Gates Pond on old maps. Capt. William Gates resided here and was head of the local militia. He built many of the area's long-enduring homes and barns from white oak. Two sachems also lived here. In these waters, the first baptism of Marlborough's Baptist church took place in 1866.

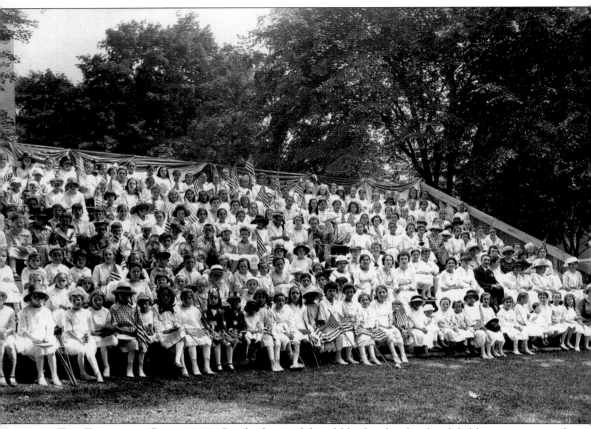

THE FOURTH OF JULY 1919. On the lawn of the old high school, schoolchildren are prepared to sing a welcome concert to soldiers returning from World War I. In the front row is a pair of crutches and Uncle Sam.